MW00389720

RIVERFRONT
STADIUM

Home of the Big Red Machine

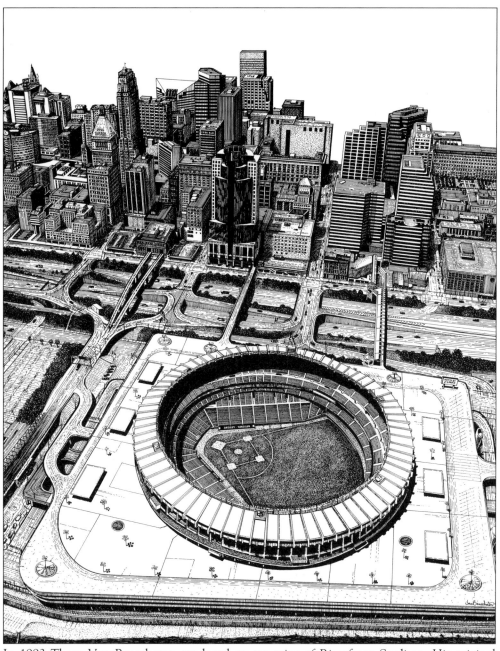

In 1993 Thom Van Benschoten produced an art print of Riverfront Stadium. His original drawing was based on a photo taken from a blimp by Janine Spang.

RIVERFRONT STADIUM

STADIUM

Home of the Big Red Machine

Mike Shannon

ARCADIA

Copyright © 2003 by Mike Shannon.
ISBN 0-7385-2324-0

First Printed 2003.
Reprinted 2003.

Published by Arcadia Publishing,
an imprint of Tempus Publishing, Inc.
Charleston SC, Chicago, Portsmouth NH,
San Francisco

Printed in Great Britain.

Library of Congress Catalog Card Number: 2003108538

For all general information contact Arcadia Publishing at:
Telephone 843-853-2070
Fax 843-853-0044
E-Mail sales@arcadiapublishing.com
For customer service and orders:
Toll-Free 1-888-313-2665

Visit us on the internet at http://www.arcadiapublishing.com

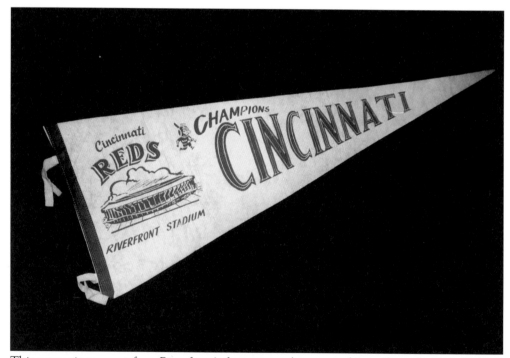

This souvenir pennant from Riverfront's first season shows two things. One, the Reds became winners right away in their new home. And two, the Stadium immediately became a symbol of the team. (Courtesy of Tiffany L. Schulz.)

CONTENTS

ACKNOWLEDGMENTS

Much more than usual, I am indebted to others for their help in producing this book. Michael Wilger of Visual History Gallery (www.vhgallery.com) was the first person I approached, and he was so gracious and generous with both his time and his resources that I was encouraged to continue with the project. Greg Rhodes, a loyal friend and the caretaker of a wonderful collection of baseball photos shot by the late Jack Klumpe, was also very kind and generous; as was Chance Brockway. Mr. Brockway is best known for his photos of Ohio State University athletics, which he has been taking for 50 years; yet his pictures of major league baseball players are some of the most beautiful I have ever seen. I am also especially grateful to Steve Helwagen and Frank Moskowitz of *Reds Report*; to Rick Block (e-mail: signsscene@yahoo.com), the brains behind the "Signs Scene at Riverfront Stadium" poster; to Dr. G. Russell Frankel of the "Cinergy Trilogy" poster; to Ken Schenk; and to Bob Bruckner for the use of many of the photos in the book.

In addition, I wish to thank the following for their important contributions: Alice Bersch and Doreen Lawson of Disabled American Veterans, Mark Bowen, Don Cruse, Kevin Grace, Deron Grothaus of the Collector's Connection, Scott Hannig of Pastimes Scoreboards (www.pastimesscoreboards.com), Tim Hoard, Dena Holland, Tom Juengling, Clay Lurachi of the Topps Company, Hal McCoy, Tom O'Connell of *Sports Collectors Digest*, Pete of Pete's Photo World, Tom Pfirrman of Baseball Card Corner, Richard "Moe" Ryan, Jeff Sacks of All Star Cards & Collectibles (954-252-1919), Glenn Sample, Tiffany L. Schulz, Casey Shannon, Charles Soto, Joann Spiess, Shari Steinhaus of Antonelli College of Photography, Helen Thomas of Baseball on the Skywalk, Thom Van Benschoten (e-mail: lcvanb@cinci.rr.com), and Steve Wolters.

One of the most famous names in photography in Cincinnati is that of Sarge Marsh, a life-long resident of the Queen City who began his career as a newspaper photographer in 1937. An innovative practitioner in all aspects of the photographic arts and an expert at aerial photography, Marsh has entrusted the care and dissemination of his photos to Visual History Gallery in Cincinnati. It is a privilege for me to be associated in this book with such an artist.

Although I consulted too many works to list them all here, I must mention the ones which proved to be exceptionally helpful: *Baseball by the Numbers* by Mark Stang and Linda Harkness; *Big Red Dynasty* by Greg Rhodes and John Erardi; *Cincinnati and the Big Red Machine* by Robert Harris Walker; *Crosley Field* by Greg Rhodes and John Erardi; *Redleg Journal* by Greg Rhodes & John Snyder; *Total Baseball* by John Thorn, et al; *The World Series* by David S. Neft and Richard M. Cohen; and various editions of Cincinnati Reds media guides.

Finally, I wish to thank all the folks at Arcadia who helped create this book, especially Editor Jeffrey M. Ruetsche, who was unfailingly patient and encouraging. And, as always, my deepest gratitude goes to my family: my wife, Kathy, and our children, Meg, Casey, Mickey, Babe, and Nolan Ryan Shannon; my parents, John and Willie Shannon; and my sisters and brothers, Sis, Susie, John, and Tim.

INTRODUCTION

In 1986 the Society for American Baseball Research published Philip J. Lowry's *Green Cathedrals*, a book which Lowry described as "being a statistical and anecdotal celebration of the hundreds of grass palaces where major league, Negro league, and selected minor league baseball has been played." Although Lowry briefly examines Riverfront Stadium in his book, Riverfront did not qualify in his mind as a "Green Cathedral" or a "grass palace." In fact, according to Lowry, Riverfront was everything that a ballpark should not be: Riverfront was a multi-purpose super stadium (not an intimate park); it had an artificial playing surface (not real grass); and it was located on the banks of a mighty river and had ample parking nearby (not in a dense urban setting with a minimum of adjacent parking).

And Lowry wasn't the only detractor. Riverfront Stadium was a sports facility that received very few valentines in its day from anybody. And yet, Riverfront is a stadium that deserves to be remembered...and, yes, even celebrated; for it did much more than merely serve its purpose. Riverfront Stadium reflected the times, the city which built it, and the team which called it home. It became almost immediately one of Cincinnati's most photogenic landmarks, as well as a visual synonym for the city's professional baseball team.

Riverfront was also a good place to watch a ballgame. The upper deck red seats became known pejoratively as the "nose bleed section," but even from that elevated vantage point the view was pretty good. Riverfront had other pluses: it was convenient, easy to keep clean, and dependable (because of its artificial surface Riverfront averaged barely one rain out per year). Moreover, tickets at Riverfront were usually much more plentiful than they ever had been at Crosley Field, and the Reds did an outstanding job of keeping them among the most affordable in the major leagues.

Most important of all, Riverfront was the scene of some of the greatest events in baseball history. It was the home of baseball's best modern team, the Big Red Machine, and the only home of the Cincinnati Reds that an entire generation of fans has ever known. Riverfront Stadium may not have been architecturally grand or especially unique, but it was a special place for the glorious things that happened there. It is gone, but it will not be forgotten.

Riverfront Stadium officially became "Cinergy Field" in 1996, but the name change never took with many die-hard fans, including the author; who asks the reader to overlook his obstinence in using the original name of the ballpark throughout the book.

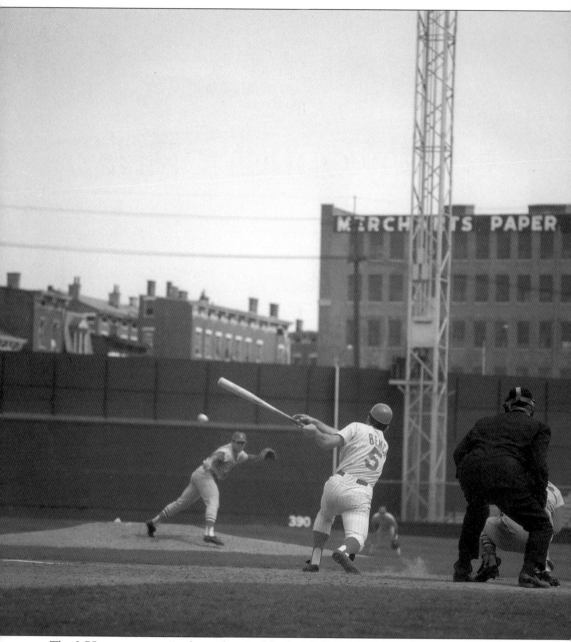

The I-75 expressway wiped out the neighborhood that was once right across the street from Crosley Field's outfield walls, but old buildings farther away still made their presence felt in 1967. (Courtesy of Visual History Gallery.)

ONE

Goodbye Crosley Field

Before Riverfront Stadium, there was Crosley Field, an unpretentious little ballyard on the corner of Findlay and Western Avenues that served as home of the Cincinnati Reds for 58 halcyon summers. Located on the City's west side, Crosley sat on the site of an abandoned brickyard where professional baseball had been played in Cincinnati since 1884. Crosley was actually the same ballpark as Redland Field, the city's first concrete and steel baseball park, which had been erected in 1911-12. The name change occurred in 1934 when the Reds were purchased by inventor and business tycoon Powel Crosley, Jr.

Crosley, like the other classics constructed during the ballpark boom of 1909-23, was built in the middle of a pre-existing neighborhood and had to conform in shape and size to streets already laid out. The asymmetry of Crosley's outfield dimensions was thus par for the course. Not so some of the place's other idiosyncrasies, such as the "Sun Deck," the sawed-off right field bleachers; the "Goat Run," a section of seats placed in front of the right field bleachers in a ploy to increase home run production; the famous incline in front of the outfield walls that gave visiting outfielders fits; and the humongous scoreboard (built in 1957) in left-center field that dwarfed the players. These quirks and especially the place's coziness endeared Crosley to Cincinnatians, who also witnessed some pretty interesting events at Crosley over the years.

Crosley hosted four World Series (1919, 1939, 1940, and 1961), including the infamous 1919 Series thrown by the Chicago "Black Sox"; two All-Star Games (1938 and 1953); the first night game in major league history (May 24, 1935); and a Beatles concert. Reds fans at Crosley saw Johnny Vander Meer spin the first of his consecutive no-hitters (June 11, 1938); they saw the youngest player in history, a 15-year-old pitcher named Joe Nuxhall, make his major league debut (June 10, 1944); and they saw the longest game in team history, a 21-inning 1–0 marathon loss to the San Francisco Giants (September 1, 1967).

As beloved as Crosley Field was, by the mid-1950s the push to replace it had begun. The deterioration of the neighborhood around Crosley Field, societal changes—particularly the exodus to the suburbs and the exploding popularity of the automobile—and the inadequacies of Crosley itself combined to doom the ballpark. Nevertheless, as the Reds played out the string at Crosley in the 1960s, the feeling among the players and the fans was that Crosley's replacement was going to have a tough act to follow.

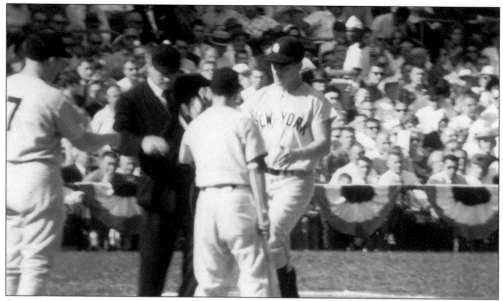

Roger Maris, being congratulated by Mickey Mantle, has just hit the ninth-inning home run that would give the New York Yankees a 3–2 victory over the Reds at Crosley Field in the third game of the 1961 World Series, the last Fall Classic ever played at Crosley. Reds' starter Bob Purkey went all the way and gave up only six hits, but an eighth-inning pinch-hit homer by John Blanchard and Maris' blast did him and the Reds in. Sidelined the first two games with an abscess on his right hip, Mantle was playing for the first time in the Series. He batted a total of six times and collected one hit, a single in Game Four, also at Crosley Field. (Courtesy of Visual History Gallery.)

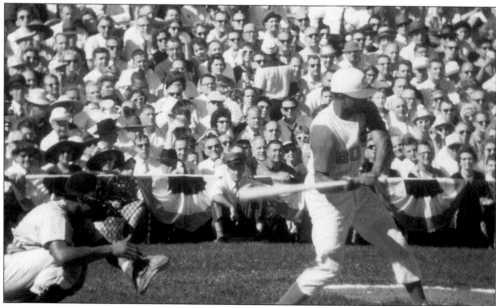

Frank Robinson, batting here in Game Three, hit only .200 in the Series against the Yankees, but the Reds would never have won the pennant without him. During the regular season Robinson hit .323 with 37 homers, 124 RBI, 117 runs scored, and 32 doubles. For his efforts he was named the National League's Most Valuable Player. (Courtesy of Visual History Gallery.)

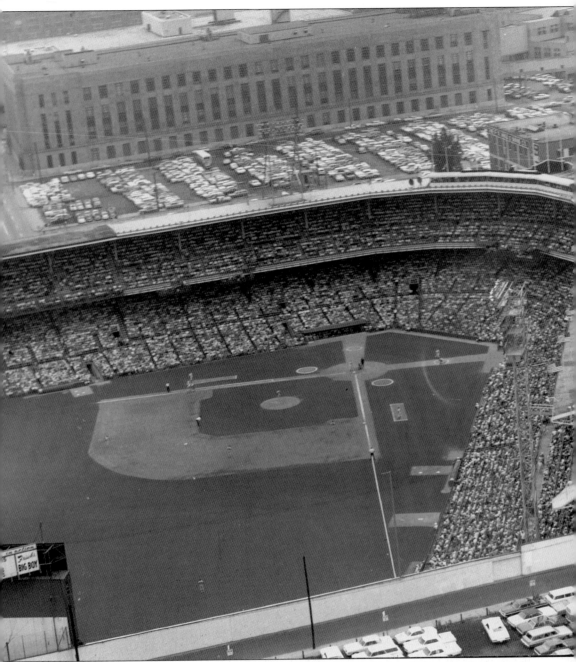

There are several things to note about this late-era Crosley Field aerial shot. First, the long building at the top of the picture is the Dalton Street post office, still in operation as this book goes to press. Second, Crosley's press box, which opened in 1937 with room for 65 people, can be seen on top of the grandstand roof. And finally, the way the grandstand roof down the first base line changes color is a tell-tale sign that the upper decks were extended over the single-deck pavilions back in 1939, just in time to provide additional seating for the World Series that year between the Reds and the New York Yankees. (Courtesy of Visual History Gallery.)

Popular outfielder Vada Pinson was a tremendous player for ten years (1959-68) during the Crosley era. As a Red, he collected more than 200 hits in a season four times (he led the NL in hits twice) and hit over .300 four times (with a high of .343 in 1961). He played for four other

major league teams in his 18-year career and finished with 2,757 hits, 256 home runs, and 305 stolen bases. Note the columns in the grandstands which held up the upper deck and resulted in more than a few view-obstructed seats. (Courtesy of Visual History Gallery.)

The columns in classic ballparks like Crosley Field may have ruined the views of some fans, but they enhanced the views of thousands of other fans by keeping upper decks directly overhead of lower ones, and thus closer to the playing field. This photo of Pete Rose standing by the dugout bat-rack demonstrates the intimacy between fans and players that was the hallmark of Crosley Field. (Courtesy of Visual History Gallery.)

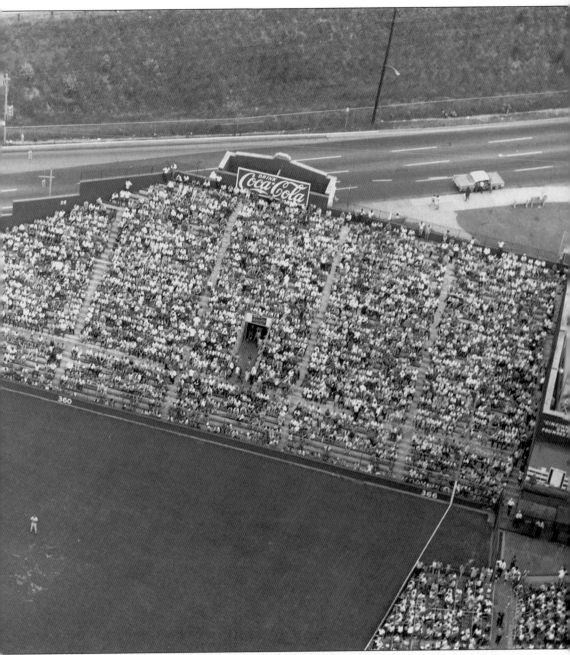

Crosley Field had many quirks, among them this small section of bleachers on Western Avenue in the right field corner. In the mid-1950s it became affectionately known as the "sun deck." During night games fans referred to it as the "moon deck." The 366-foot distance down the line was the longest among NL ballparks. A Sun Deck ticket cost 75¢ in 1959. The original Reds' ballpark at the site of Crosley Field, which opened in 1884, had its home plate incorrectly situated in this right field corner. Home plate was in the wrong location then because the sun shone in the batters' eyes. (Courtesy of Visual History Gallery.)

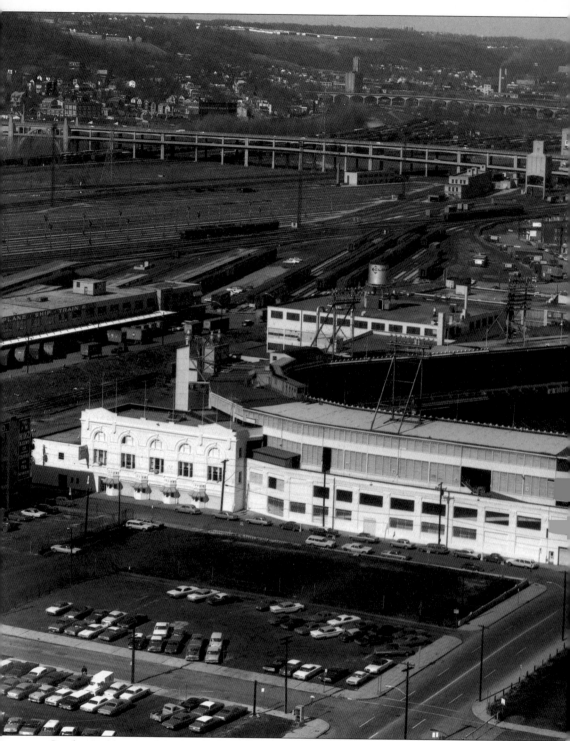

Crosley Field was architecturally designed to blend into a thriving, working class neighborhood of red-brick residential and business buildings. Towards the end of its existence, bounded by parking lots, rail yards, and the I-75 expressway, it was like a single flower standing resolutely in

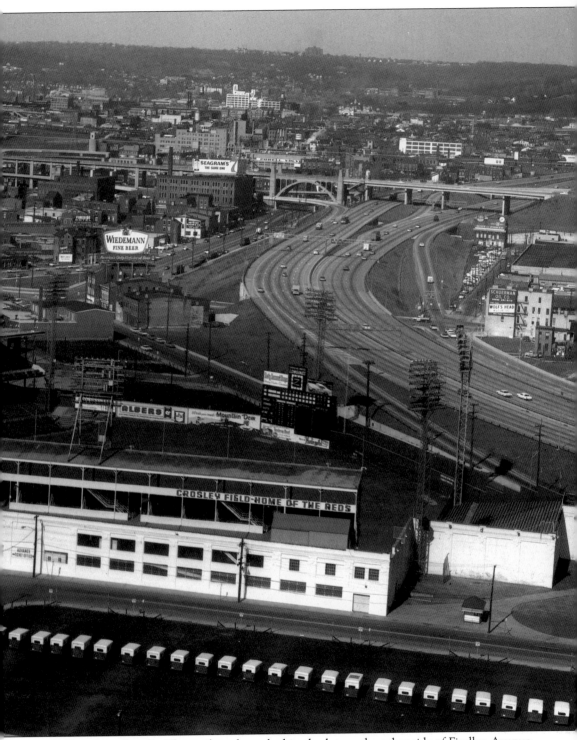

a crack in the sidewalk. The mail trucks parked in the lot on the other side of Findlay Avenue are an indication that this photo was shot in the off-season. (Courtesy of Visual History Gallery.)

With Crosley Field's famous Longines-topped scoreboard towering above them in the background, a trio of great players react to a passed ball … or more likely, given the exceptional catching ability of even a young Johnny Bench, a wild pitch. Here is Lou Brock as he is coming into his prime. He led the National League in stolen bases eight times, amassed over 3,000 hits, and was voted into the Hall of Fame. Jim Maloney was the Reds' ace from 1963 through 1969, pitched three no-hitters, and set the club single-game strikeout record with 18. Early in 1970 he suffered an injury, a ruptured Achilles tendon, which essentially ended his career, and he never won a game for the Reds in their new Stadium. (Courtesy of Visual History Gallery.)

The umpire throws out a new ball at Crosley Field, as Johnny Bench gets settled in the batter's box and Pete Rose pats the rump of Tony Perez, who has just finished his home run trot. The three Reds' stars would soon leave Crosley behind for a new ballpark: Riverfront Stadium. (Courtesy of Visual History Gallery.)

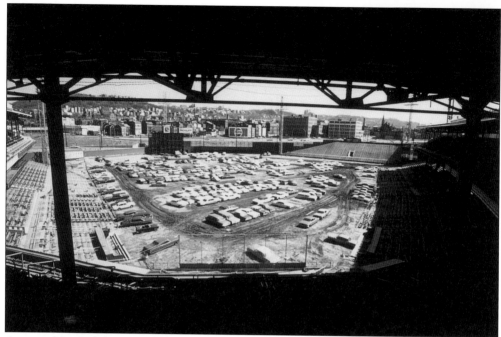

As part of the deal that provided a new ballpark for the Reds, the City of Cincinnati agreed to buy Crosley Field—it took a jury trial to establish the value of Crosley at $2.5 million. The site was eventually turned into an industrial complex, but from 1970 to 1972 the City used Crosley Field as an impoundment lot for abandoned and unclaimed autos, making a rather sad, undignified sight of the grand old place. Demolishment of Crosley Field began in April of 1972. Sitting on his father's lap, Pete Rose, Jr., age 2, began the demolition, pulling the lever that dropped the wrecking ball into the outside wall of the right field bleachers. (Visual History Gallery.)

In the years following the demise of Crosley Field, enterprising fans have come up with numerous products and keepsakes that rekindle memories of the old ballyard. One of the most ingenious of such items is this working desk clock made as a replica of Crosley Field's gigantic scoreboard. Inventor Scott Hannig was careful to have all the information on the clock duplicate what existed on the actual scoreboard when the last pitch at Crosley was thrown on June 24, 1970. Back-to-back home runs by Johnny Bench and first baseman Lee May in the bottom of the eighth off Hall-of-Fame pitcher Juan Marichal gave the Reds a 5–4 victory over the Giants. (Courtesy of Scott Hannig.)

Two

The Birth of

Riverfront Stadium

The genesis of Riverfront Stadium can be traced back to the "1948 Cincinnati Metropolitan Master Plan," which called for a massive re-development of "The Bottoms," the notorious slum of dilapidated tenements, warehouses, and factories located south of downtown Cincinnati on the banks of the Ohio River. "The Plan of '48," as it was called, proposed that The Bottoms be replaced with a highway distributor connecting I-75 and I-71, a heliport, new apartment buildings, a convention center, parks, a recreation center, a city administration building, and a new baseball stadium. Although this re-development plan was too ambitious for the City to implement, it proved prophetic in regard to where the Reds' new ballpark would eventually be located.

By the mid-1960s it was clear that Crosley Field was becoming obsolete, and there was a real danger of the team leaving town if a new ballpark wasn't built to replace it. Nevertheless, there was significant political opposition to the construction of a new baseball stadium. What turned the tide, ironically, was the city's opportunity to join the National Football League … if a new stadium worthy of an NFL franchise could be guaranteed by 1970. A feasibility study offered four alternatives for a site, but the riverfront carried the day with ease, despite some fears of a stadium on the river being subject to flooding. An intense debate about what to call the new ballpark raged for a couple of years and was not settled until five weeks before it opened. Mayor Eugene Ruehlmann, the man credited with doing the most to get the project done, wrote a letter to city council, saying: "…the citizens of Greater Cincinnati have already named the stadium. It is 'The Cincinnati Riverfront Stadium.' "

Riverfront Stadium was part of the second "Super Stadium" ballpark boom (1960-1992). Its design as a concrete, circular, multi-purpose arena was predicated by its intended use as a venue for professional football as well as professional baseball; and its striking similarity to other multi-purpose stadiums in St. Louis and Atlanta (opened in 1966), Pittsburgh (1970), and Philadelphia (1971) would provoke criticism of it as being the product of a prosaic cookie-cutter mentality. Despite such criticism, Riverfront was an immediate success in its rehabilitation of The Bottoms, its enhancement of Cincinnati's image as a big league town, and its revitalization of the Reds' regional fan base. There was only one thing missing from the team's rousing success its first half-season in Riverfront: a World Championship. That would come later.

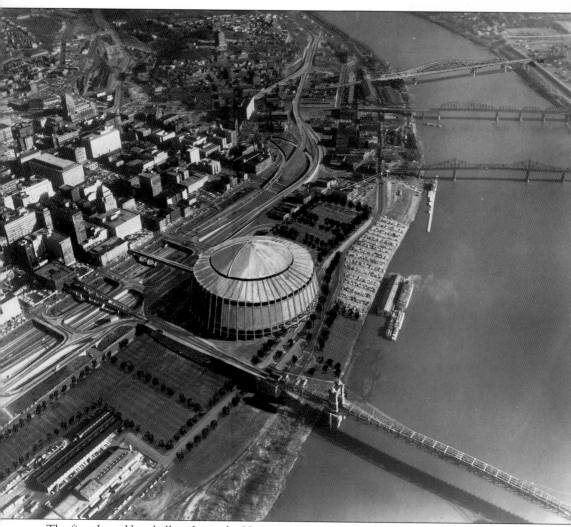

The first domed baseball stadium, the Houston Astrodome, opened in 1965. The following year there was talk about making Cincinnati's new proposed ballpark a domed stadium too. Photographer Sarge Marsh superimposed an artist's conception of a domed ballpark onto one of his photos of downtown Cincinnati to give Cincinnati City Council an idea of what such a structure might look like situated on the banks of the Ohio River. (Courtesy of Visual History Gallery.)

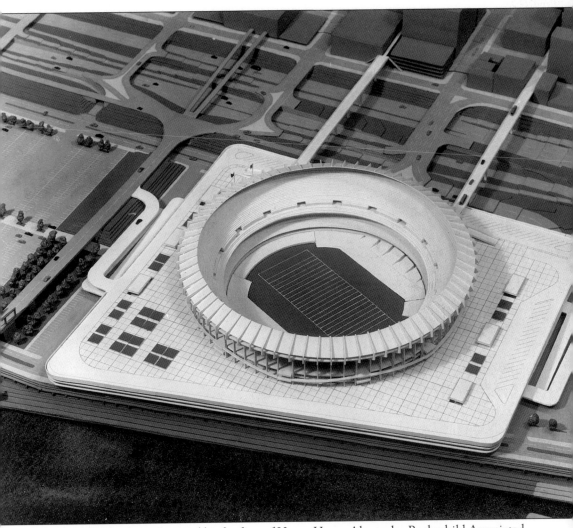

Riverfront Stadium was designed by the firm of Heery-Heery-Alexander-Rothschild Associated Architects of Atlanta, Georgia. This model of the architects' vision proved to be a highly accurate representation of the stadium that was actually constructed. The gridiron on the field and the football seating configuration indicated the dual-purpose function of the stadium, which served as the home of the NFL's Cincinnati Bengals, as well as the home of the Reds. (Courtesy of Visual History Gallery.)

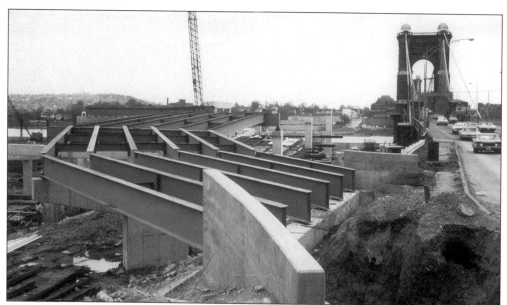

This photo, taken April 24, 1969, shows early construction of the drive built to provide automobile access to the plaza that would eventually surround Riverfront. The view is from downtown Cincinnati looking south. On the right is the famous John A. Roebling Suspension Bridge, built in the late 1860s by the man who designed the Brooklyn Bridge. The Bridge is a Cincinnati landmark that became associated with Riverfront Stadium (see page 117). (Courtesy of Visual History Gallery.)

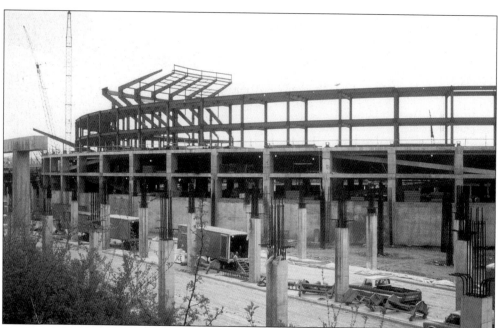

On the same April day in '69, the skeleton of the stadium itself could be seen being slowly assembled. At this point only a few of the support beams for the canopy are in place. Some of the more than 70 miles of foundation piles upon which the Stadium complex was built can be seen in the foreground. (Courtesy of Visual History Gallery.)

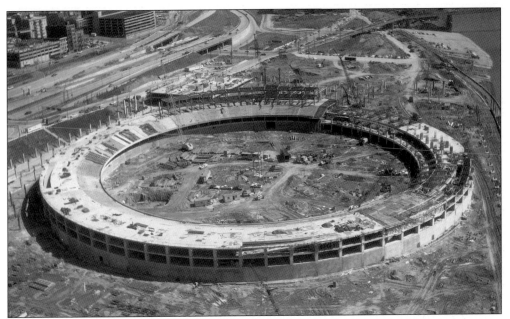

Riverfront Stadium's circular shape was from the beginning the dominant feature of the new ballpark, as this aerial view fairly early in the construction process makes clear. By the time it was finished, the massive project used 10,000 tons of steel, 13,000 tons of reinforcing steel, and 175,000 cubic yards of concrete. The complex took up a total of 48 riverfront acres. (Courtesy of Visual History Gallery.)

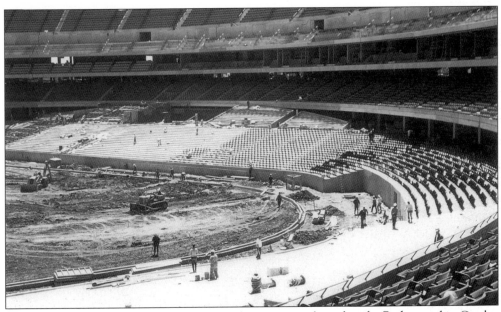

A year later a lot of progress had been made, but not enough, and so the Reds stayed in Crosley Field for the first three months of the 1970 season. Most conspicuously absent are the as-yet uninstalled field level blue seats and the Astroturf playing surface. Riverfront was the first outdoor baseball stadium to use artificial turf over the entire field, and it took 120,000 square feet of the stuff to do the job. (Courtesy of Visual History Gallery.)

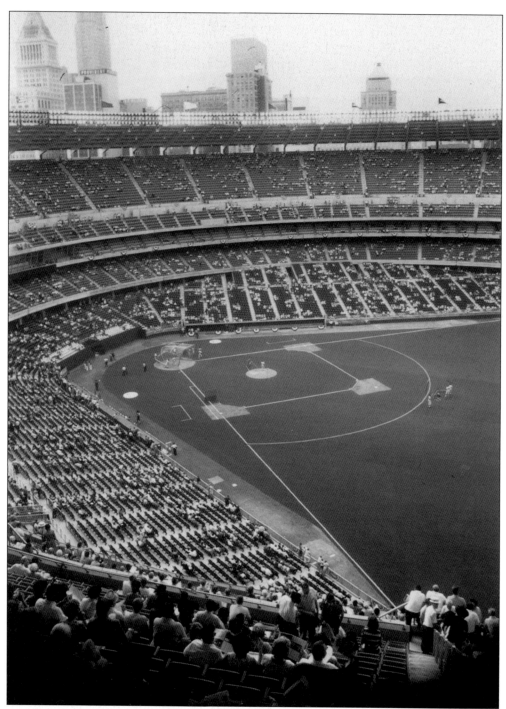

Riverfront opened on June 30, 1970, and 51,050 fans showed up to get their first look at the Reds' new home. Although construction was not finished and numerous bugs remained to be worked out, the spacious stadium made a dramatic contrast to its predecessor. The stadium was completely enclosed, but part of the Cincinnati skyline could be seen looming above the ring of lights on the roof, a constant reminder of Riverfront's urban setting. (Courtesy of Visual History Gallery.)

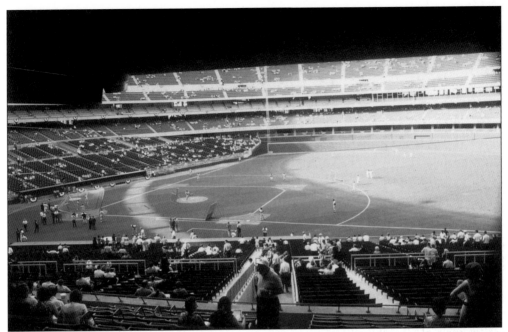

Even from the concourse behind the green seats one was afforded a good view of the diamond, which made it possible for fans on the green seat plaza level to keep their eyes on the action for most of the walk to restrooms or concession stands. This is Riverfront's Opening Night, and the early birds are watching the Atlanta Braves take batting practice in the late afternoon. (Courtesy of Visual History Gallery.)

Ticket takers man the turnstiles just inside one of Riverfront's 13 public gates on the green seat plaza level. Riverfront was a four-tiered stadium, with color-coded seating. After passing through one of the gates, fans walked up a pair of ramps to get to the Loge Level (the upper deck red seats) or down ramps to get to the Field Level blue seats. Yellow seat boxes were located between the green and red levels and were reached by walking up one ramp. The original official capacity of Riverfront Stadium was 51,744, but this figure was routinely surpassed over the years. (Courtesy of Rick Block.)

The administrative offices of the Reds were located at the Stadium, and the main entrance was reached by walking through the ground level parking lot beneath the Plaza Level. Note the reference to 1869, which subtly calls attention to the organization's proud heritage as baseball's first professional team. (Courtesy of Rick Block.)

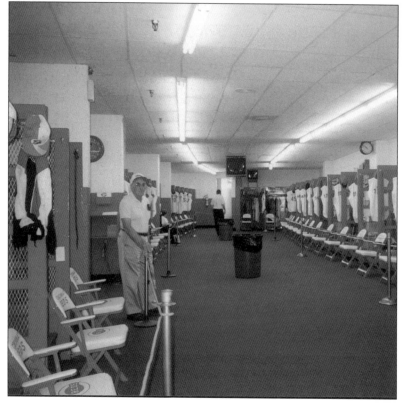

When the fans were coming in on a tour of Riverfront, the red-carpeted home team clubhouse looked pretty spiffy. Things weren't quite so tidy after a game. Players' lockers are considered sacrosanct, and all media people and hangers-on know the unwritten rule that forbids touching any equipment or possessions belonging to the players. (Courtesy of Joann Spiess.)

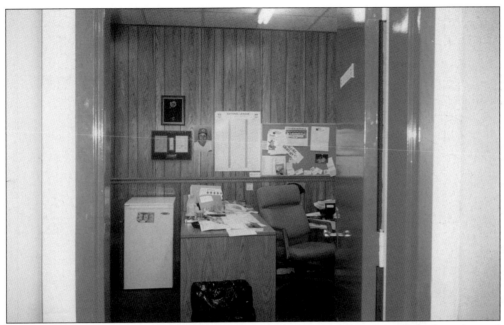

The Reds had 12 managers during the Riverfront era, and the office they all used was located off a short hallway between the players' clubhouse and a lobby where wives and girlfriends could wait. After most every game reporters would cram into the office to ask the manager questions. This is how the place looked when Jack McKeon was the head honcho. (Courtesy of Joann Spiess.)

When Bob Howsam named George "Sparky" Anderson the new manager of the Reds in October of 1969, Cincinnati newspaper headlines shouted "SPARKY WHO?" The 35-year-old Anderson had played one year in the major leagues as a weak-hitting second baseman and had managed a few years in the minors. Despite his relative anonymity, Anderson quickly proved his mettle, demonstrating that he was a master psychologist, a shrewd motivator, and an excellent judge of talent. One of the truly nice guys to ever don a baseball uniform, Sparky was never afraid to vehemently present his case to the authorities in blue. (Courtesy of Bob Bruckner.)

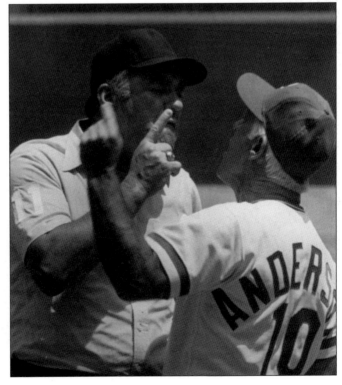

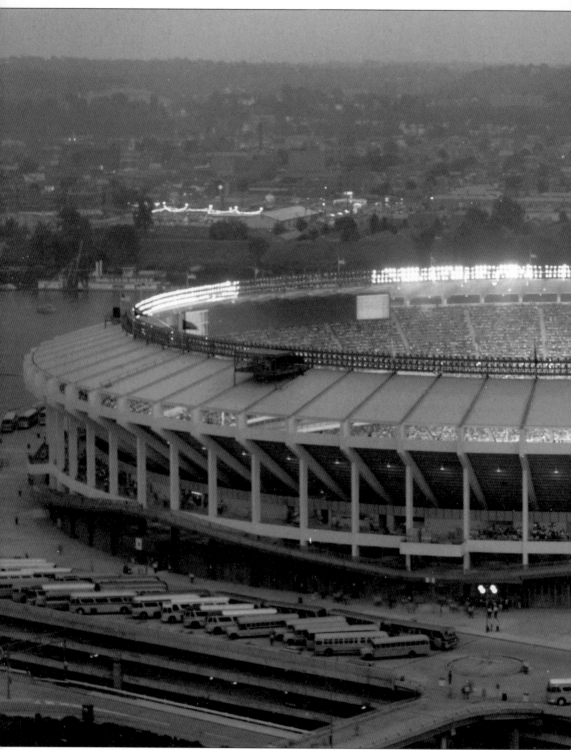

This is the view of the brand new Riverfront Stadium on Opening Night from downtown Cincinnati. Note the buses lined up on the perimeter of the plaza and the two levels of parking

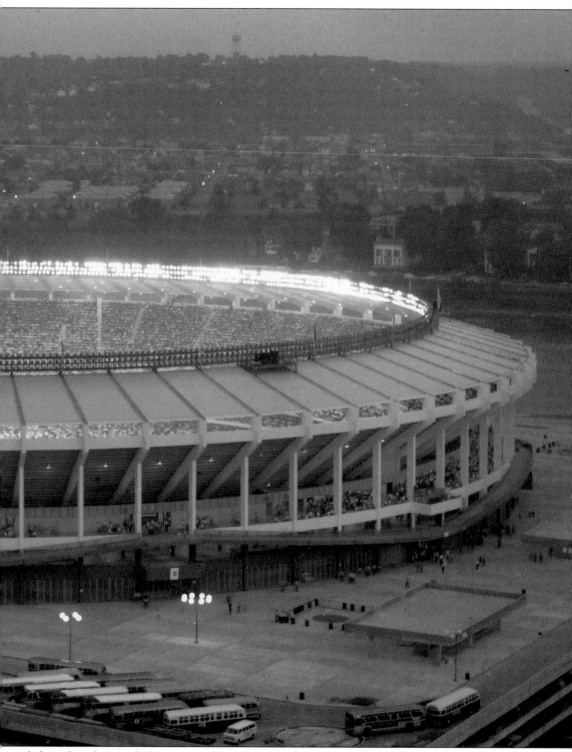

below the plaza and above ground level, a concession to the predominantly suburban and automobile-loving fan base the Stadium was built to serve. (Courtesy of Visual History Gallery.)

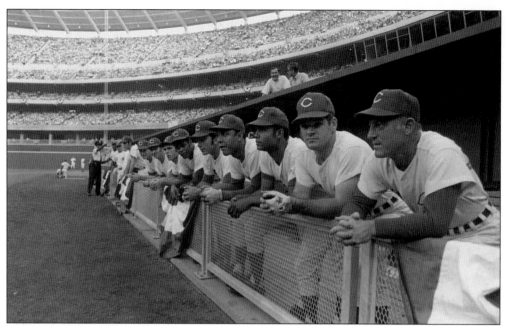

Looking undazzled by their glamorous new stage, the Reds' starting lineup posed for a picture on Opening Night while leaning over the railing in front of the first base dugout. From left to right are pitcher Jim McGlothlin (standing upright), Woody Woodward, Tommy Helms, Bernie Carbo, Lee May, Johnny Bench, Tony Perez, Bobby Tolan, Pete Rose, and manager Sparky Anderson. (Courtesy of Jack Klumpe/ Road West.)

Hank Aaron wasted little time in testing the dimensions of Riverfront. Here he is, in the top of the first inning on June 30, 1970, about to hit the first home run ever in the Stadium. It was the 577th of his career. Cincinnati was always a special place for Aaron. He'd played his first major league game at Crosley Field, and earlier in the year he had collected the 3,000th hit of his career there. One more big Aaron moment in Cincinnati was yet to come. (Courtesy of Jack Klumpe/ Road West.)

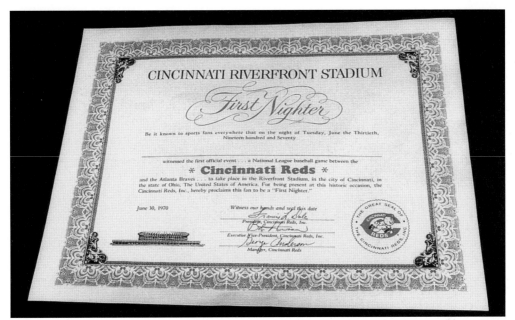

Fans on hand for the National League game that officially opened Riverfront were given a "First Nighter" certificate of attendance, bearing an image of the Stadium in the lower left-hand corner and the facsimile signatures of ballclub President Francis L. Dale, Executive Vice-President Bob Howsam, and Manager George Anderson. The Reds later gave out similar certificates of attendance to mark other special occasions, such as Tom Seaver's 3,000th strikeout, Johnny Bench's retirement, and Pete Rose's first game as the Reds Manager/Player. (Courtesy of Tiffany L. Schulz.)

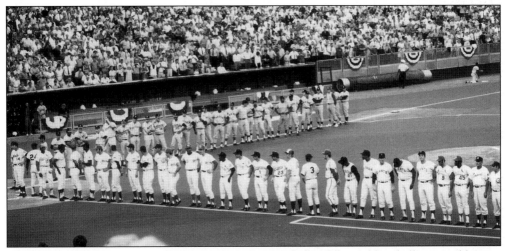

Two weeks after Riverfront Stadium opened, the new ballpark hosted baseball's second biggest event, the All-Star Game. Both rosters, shown lined up on the base lines, were packed with future Hall of Famers: Hank Aaron, Johnny Bench, Roberto Clemente, Bob Gibson, Willie Mays, Willie McCovey, Joe Morgan, Tony Perez, Gaylord Perry, Tom Seaver, and Hoyt Wilhelm, representing the National League; and Luis Aparicio, Rod Carew, Catfish Hunter, Harmon Killebrew, Jim Palmer, Brooks Robinson, Frank Robinson, and Carl Yastrzemski, representing the American League. (Courtesy of Visual History Gallery.)

33

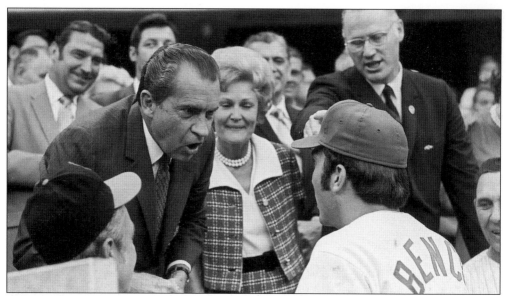

As Commissioner Bowie Kuhn looks on, Johnny Bench has a chat with Richard M. Nixon after the President has thrown him the ceremonial first pitch of the 1970 All-Star Game. Nixon, who truly loved the game, was once offered the job of baseball commissioner but reluctantly turned it down. The year before, in 1969, he was given a trophy by Kuhn that saluted him as "Baseball's Number 1 Fan." To prove his knowledge of baseball history, Nixon selected personal All-Star squads by eras. He named Bench as his NL catcher for the Modern Era. (Courtesy of Chance Brockway.)

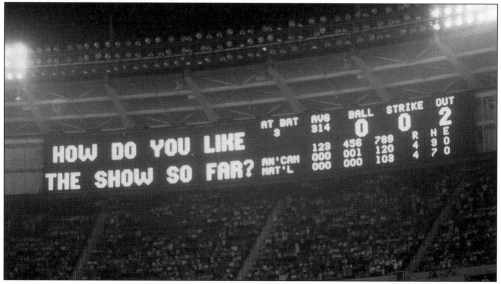

The question asked by Riverfront's main, center field scoreboard was prompted by the National League's having scored three runs in the bottom of the ninth inning to tie the game 4–4 and send it into extra innings (for the sixth time in All-Star Game history). Reds' fans quickly became accustomed to being constantly informed and entertained by messages on the scoreboard. Messages about player milestones and the "Scoreboard Stumper" trivia questions were fan favorites. (Courtesy of Visual History Gallery.)

34

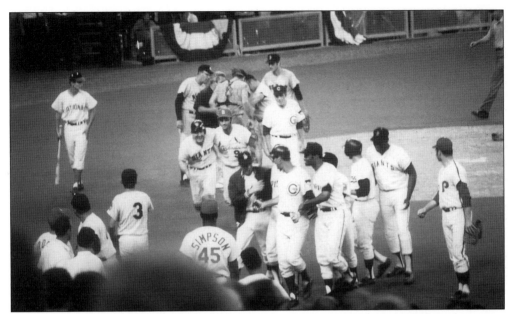

The 1970 All-Star Game ended when Pete Rose ran over Cleveland catcher Ray Fosse to score the winning run with two outs in the bottom of the 12th inning. Racing from second on a single to center by the Cubs' Jim Hickman, Rose crashed into Fosse, who was blocking the plate, just as he caught the throw from the Royals' Amos Otis. The collision knocked the ball out of Fosse's hands. The tough-but-clean play was classic Pete Rose, who always played to win. As American League personnel attend to the injured Fosse, jubilant National Leaguers celebrate the win. Oddly, Pete Rose is nowhere to be seen. (Courtesy of Visual History Gallery.)

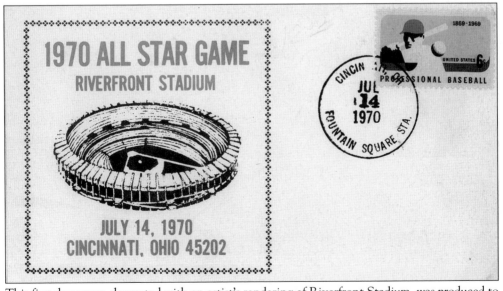

This first day cover, decorated with an artist's rendering of Riverfront Stadium, was produced to commemorate the 1970 All-Star Game played in Cincinnati's new ballpark. It was postmarked on July 14, the day of the game, at the Fountain Square Station in downtown Cincinnati. Adding to the collectibility of the piece is the envelope's 6¢ stamp, issued the year before, to commemorate the 100th anniversary of professional baseball. (Courtesy of Tiffany L. Schulz.)

A good crowd, though not quite a sell-out, is on hand for this game between the Reds and the Chicago Cubs in August of 1970. Not yet in place are signs on the tops of the dugouts and on either end of the center field scoreboard. The scoreboard is flashing a message about an

upcoming special event on August 16: Ball Day, when "20,000 fine quality baseballs will be given to boys and girls 14 and under when accompanied by a separate paying adult." (Courtesy of Visual History Gallery.)

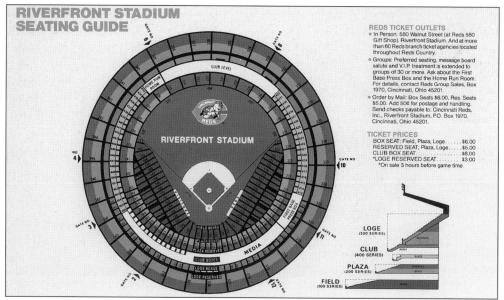

RIVERFRONT STADIUM
SEATING GUIDE

REDS TICKET OUTLETS
• In Person: 580 Walnut Street (at Reds 580
 Gift Shop), Riverfront Stadium. And at more
 than 60 Reds branch ticket agencies located
 throughout Reds Country.
• Groups: Preferred seating, message board
 salute and V.I.P. treatment is extended to
 groups of 30 or more. Ask about the First
 Base Press Box and the Home Run Room.
 For details, contact Reds Group Sales, Box
 1970, Cincinnati, Ohio 45201.
• Order by Mail: Box Seats $6.00, Res. Seats
 $5.00. Add 50¢ for postage and handling.
 Send checks payable to: Cincinnati Reds,
 Inc., Riverfront Stadium, P.O. Box 1970,
 Cincinnati, Ohio 45201.

TICKET PRICES
BOX SEAT: Field, Plaza, Loge $6.00
RESERVED SEAT: Plaza, Loge $5.00
CLUB BOX SEAT $8.00
*LOGE RESERVED SEAT $3.00
 *On sale 3 hours before game time

With this color-coded seating guide to Riverfront Stadium a Reds' fan could get a pretty good idea of where his seats were. The diagram in the lower right-hand corner illustrates the four levels of the Stadium. This seating guide lists ticket prices for 1981 that ranged from $3 (for Loge Reserved) to $6 (for Box Seats: Field, Plaza, Loge). (Courtesy of Don Cruse.)

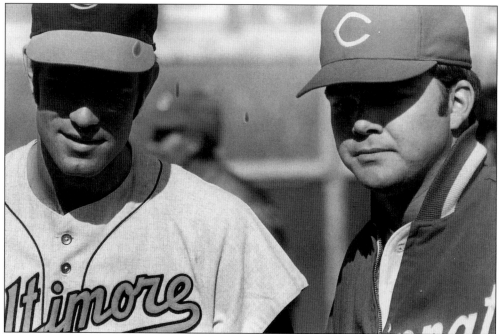

Pitchers Jim Palmer and Gary Nolan pose for the cameras before starting the first game of the 1970 World Series at Riverfront. Both were staff aces, Palmer having gone 20–10 in the regular season and Nolan, 18–7. Both pitchers allowed five hits, but Palmer scattered his over 8 2/3 innings and got credit for the Orioles' 4–3 win; while Nolan blew a 3–0 lead, surrendering home runs to Boog Powell, Ellie Hendricks, and Brooks Robinson. (Courtesy of Jack Klumpe/ Road West.)

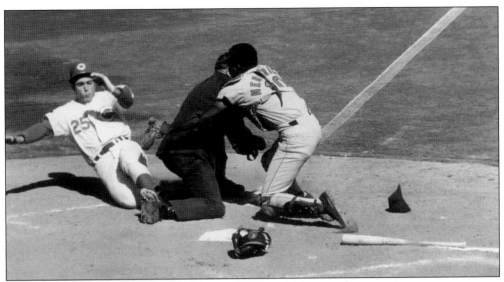

One of the most controversial plays in World Series history happened in Game One. It was a bad call by umpire Ken Burkhardt, which probably cost the Reds the ballgame. In the sixth inning the Reds had runners on first and third with one out when Ty Cline chopped a high bouncer in front of the plate. Orioles' catcher Elrod Hendricks fielded the ball, but when he lunged at a sliding Bernie Carbo he found Burkhardt in his way. Without seeing the play properly Burkhardt called Carbo out. Replays and photographs showed that Hendricks did tag Carbo but with an empty glove. The ball stayed in his right hand. Carbo missed the plate on his slide, but he'd been blocked by Burkhardt, and he became technically safe when he stepped on the plate during the ensuing argument. (Courtesy of Jack Klumpe/ Road West.)

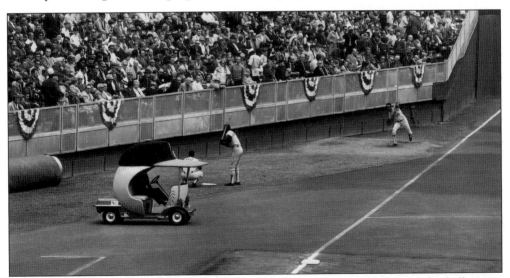

As demonstrated by the Orioles' Mike Cuellar, warming up before Game Two, the bullpens in Riverfront Stadium were located in foul ground down the third and first base lines. Reds' GM Bob Howsam felt that having the pitchers, and especially relief pitchers, warm up in full view of the fans would add an element of anticipation as well as an opportunity for second-guessing to the games at Riverfront. The baseball cap-topped golf cart waiting to taxi Cuellar to the mound was a cute fad of the '70s that really wasn't necessary at Riverfront. (Courtesy of Jack Klumpe/ Road West.)

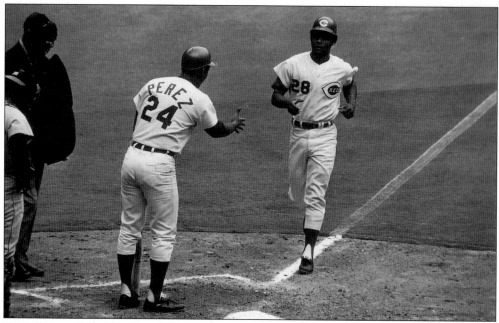

Tony Perez congratulates outfielder Bobby Tolan, whose solo home run to right field against Cuellar to lead off the third inning has given the Reds a 4–0 lead in Game Two of the Series. Tolan led all Reds hitters with a .417 average in the three-game sweep of the Pittsburgh Pirates in the NLCS. Tolan, who had come to the Reds with Wayne Granger in the trade of Vada Pinson to the Cardinals, had a career year in 1970, establishing his highs in batting average (.316), doubles (34), runs scored (112), and bases on balls (94). He also led the NL in stolen bases with 57. (Courtesy of Jack Klumpe/ Road West.)

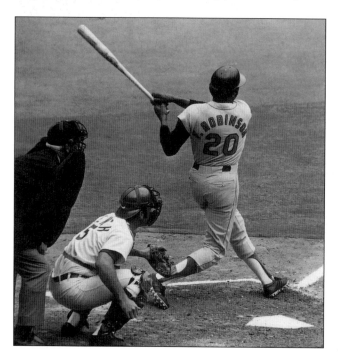

Sending Frank Robinson to Baltimore at the end of 1965 was the worst trade in Reds' history. Hardly on the downhill, Robinson won a Triple Crown, was named AL MVP, and led the Orioles to their first World Championship in 1966. Robinson could still play four years later. He went 0 for 9 in the two games at Riverfront but 6 for 13 with two homers in Baltimore, where the Orioles ended the series, four games to one. (Courtesy of Jack Klumpe/ Road West.)

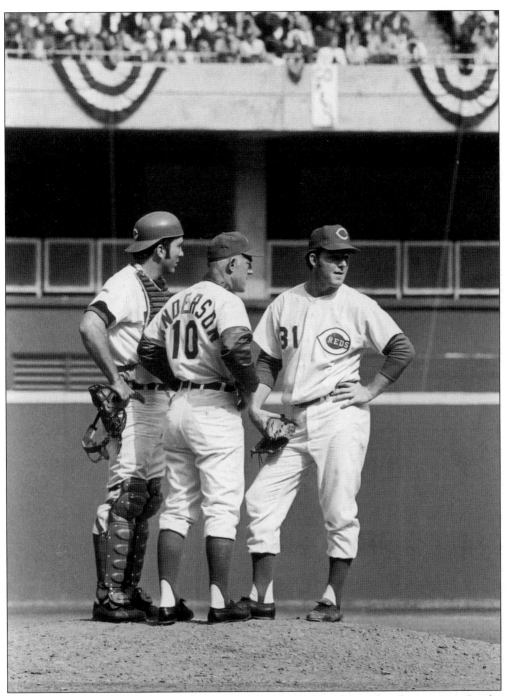

With one out and Baltimore runners on first and second, Johnny Bench, manager Sparky Anderson, and starter Jim McGlothlin look towards the Reds' bullpen for help during the fifth inning of the second game of the Series. McGlothlin left the game with the Reds leading 4–2, but before the inning ended the Orioles scored four more times. Johnny Bench's solo home run in the sixth was not enough to overtake the Orioles, who held on for a 6–5 victory. (Courtesy of Chance Brockway.)

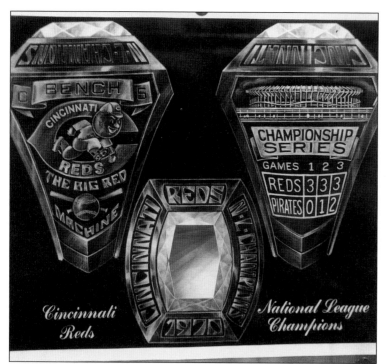

This artist's sketch of the ring the Reds were to be given for winning the 1970 National League pennant shows an engraving of Riverfront Stadium on the left shaft of the ring and is typical of how often the Reds incorporated images of Riverfront into the things the organization produced. Note that the Reds were already being called "The Big Red Machine." (Courtesy of Jack Klumpe/ Road West.)

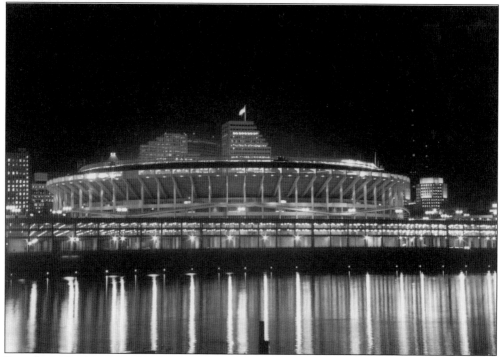

Riverfront Stadium quickly became a landmark of Cincinnati and a favorite subject of photographers trying to capture the spirit of the city. When it was lit up for a night game, Riverfront shone like a huge jewel on the banks on the Ohio River. (Courtesy of Don Cruse.)

THREE
The Big Red Machine

Two World Championships, four National League pennants, and six post-season appearances in a single decade (1970-79). That's the legacy of the Big Red Machine and the justification of the team's claim to being one of the greatest dynasties in baseball history. The World Championship teams of 1975 and 1976, led by Pete Rose, Johnny Bench, Joe Morgan, and Tony Perez, receive the greatest attention, and rightly so. The first World Series victory, an exhilarating seven-game triumph over the Boston Red Sox, transfixed the nation, elicited volumes of purple prose from writers and commentators, and validated the team as champions, after disappointments in the World Series of 1970 (vs. Baltimore) and 1972 (vs. Oakland). The Big Red Machine's awesome performance the next year, back-to-back sweeps of the NLCS and the World Series in which they dominated the Phillies and the Yankees, respectively, conferred greatness on the team and clothed them in an aura of invincibility.

The opening of Riverfront Stadium was timed perfectly to coincide with the arrival of the Big Red Machine. In fact, it can be argued that the Stadium itself contributed to the success of the team. General manager Bob Howsam certainly took the characteristics of the Reds' new ballpark into consideration in assembling the main components of the team. While the Big Red Machine became famous for its power-laden lineup, the Stadium's artificial surface made the team's extraordinary speed and defense equally important. The acquisition of second baseman Joe Morgan in a blockbuster trade with the Houston Astros typified Howsam's approach of seeking players suited to the ballpark; as Morgan was the perfect Riverfront Stadium triple-threat, capable of beating the opposition with a home run, a stolen base, or a great play in the field.

Unfortunately, the Big Red Machine was slowed in 1977 and '78 by the ill-conceived trade of Tony Perez, the further loss of key players with the advent of free agency, injuries, and the decline of the team's good-but not-great pitching staff. The team won a final divisional championship in 1979 (before losing to the Pittsburgh Pirates in the NLCS) to close its remarkable decade of excellence. Some of the worst years in Reds' history lay ahead, but the remarkable run of the 1970s was a performance which stamped Cincinnati as a city of winners and crowned Riverfront Stadium forever as the Home of the Big Red Machine.

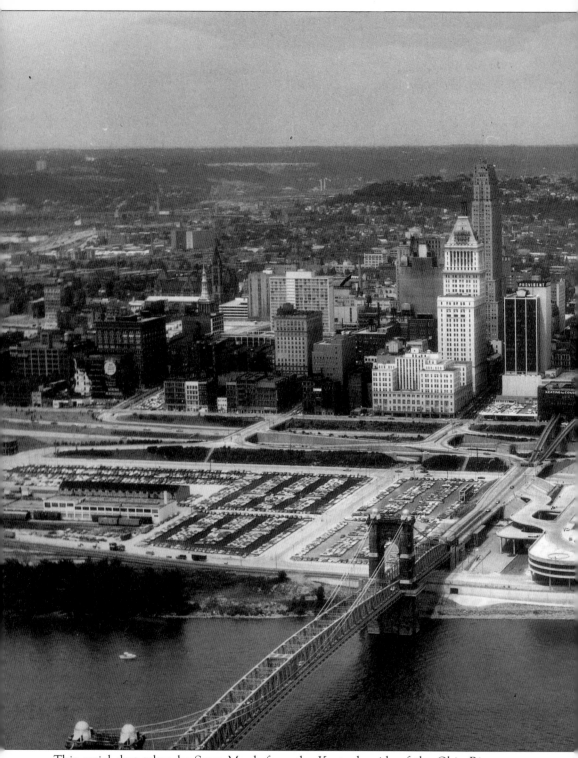

This aerial shot taken by Sarge Marsh from the Kentucky side of the Ohio River captures Riverfront Stadium's picturesque setting and demonstrates how the Stadium dominated

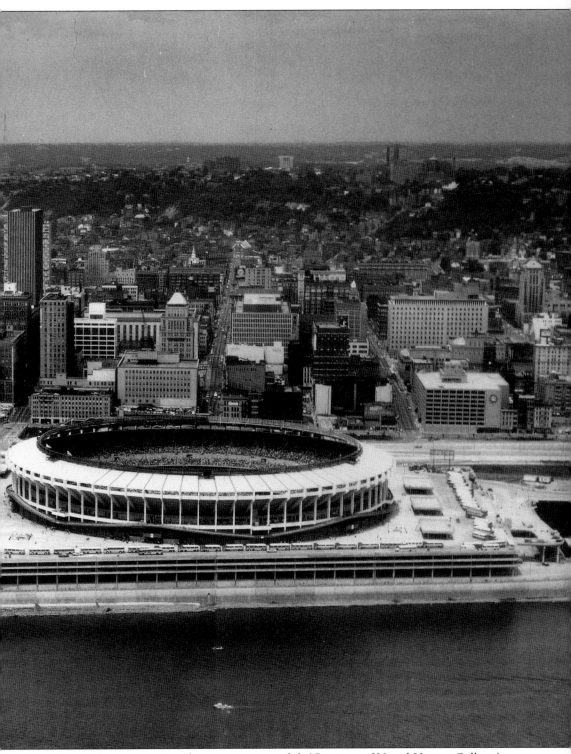

Cincinnati's door step as no other structure ever did. (Courtesy of Visual History Gallery.)

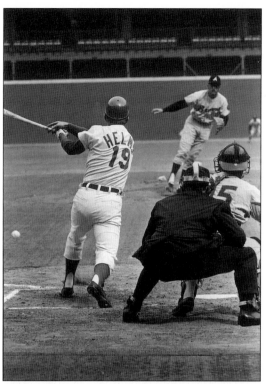

Scrappy second baseman Tommy Helms from Charlotte, North Carolina, is seen here batting against the Atlanta Braves on April 5, 1971, in the first season opener held at Riverfront Stadium. His only home run of the previous year, on July 1, was the first homer hit by a Reds' player in the new Stadium. His six-year career as a Reds' regular ended after the 1971 season when he was shipped to Houston in the eight-player trade that brought the final parts of the Big Red Machine to Cincinnati. (Courtesy of Jack Klumpe/ Road West.)

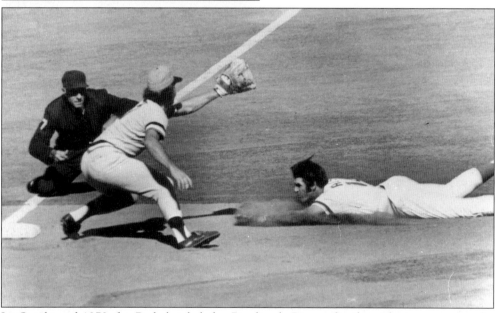

In October of 1972 the Reds battled the Pittsburgh Pirates for the right to represent the National League in the World Series. As Game Four began in Riverfront, the Pirates held a two-games-to-one edge on the Reds. In the first inning, Pete Rose performs his trademark headfirst slide into third base. Even though Richie Hebner tagged Rose out, the Reds won the game 7–1 to even the series. Rose had an outstanding NLCS, leading all batters with nine hits and a .450 average. (Courtesy of Don Cruse.)

Pinch-hitter Hal McRae is jumping for joy because George Foster has just scored the winning run of the fifth and deciding game of the NLCS from third base on a wild pitch by Pittsburgh Pirates' reliever Bob Moose. Johnny Bench's clutch home run to lead off the inning had tied the game and staved off defeat for the Reds. The young McRae batted only 97 times for the Reds in 1972, averaging .278, and was traded after the season to the Kansas City Royals, for whom he had an outstanding 14-year career as a designated hitter. (Courtesy of Chance Brockway.)

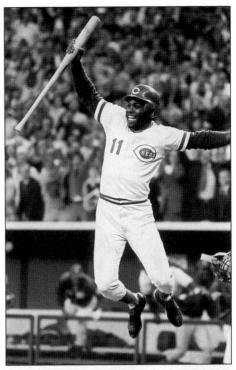

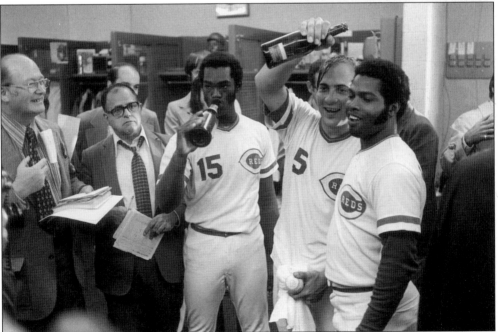

In a scene that was beginning to become very familiar in Cincinnati, the World Series-bound Reds celebrate winning the 1972 NL pennant in the home team clubhouse at Riverfront. George Foster, who has just scored the winning run in Game Five, takes a swig of champagne, while a beaming Johnny Bench performs the traditional champagne dousing on Hal McRae. (Courtesy of Jack Klumpe/ Road West.)

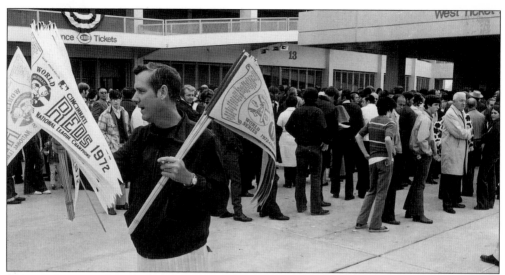

Prior to the start of the 1972 World Series, a vendor sells souvenir pennants while fans stand in ticket lines on the plaza outside Riverfront Stadium. As customary in Cincinnati, all four games of the Series at Riverfront were sell-outs. The 56,040 fans who squeezed in for Game Seven on October 22 wound up being the third largest crowd ever to witness a baseball game at Riverfront. (Courtesy of Jack Klumpe/ Road West)

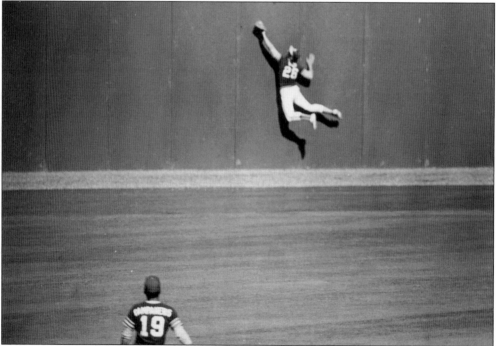

In the second game against the A's, fans at Riverfront witnessed the greatest catch in World Series history, when Joe Rudi climbed the left field wall like Spiderman and made a backhanded grab of Denis Menke's drive off Catfish Hunter. Unfortunately, the spectacular catch helped limit the Reds' ninth-inning rally to a single run, and the game ended with Oakland on top 2–1. (Courtesy of Jack Klumpe/ Road West.)

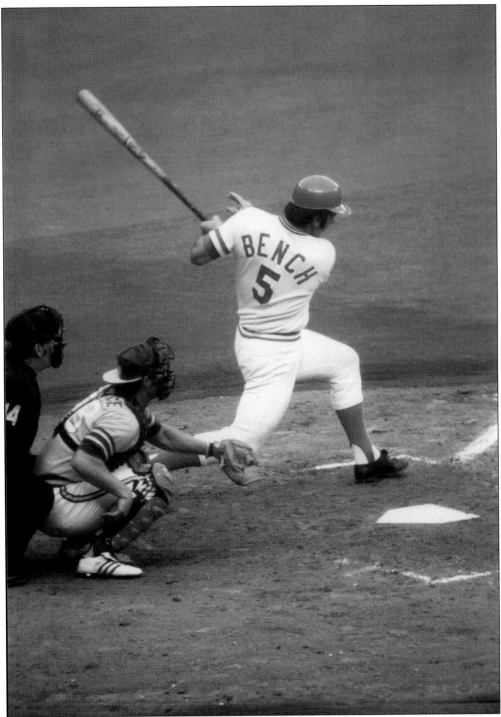

Johnny Bench lined a home run into the left field stands off Vida Blue with two outs in the fourth inning to give the Reds a 1–0 lead in the sixth game of the Series. A five-run Cincinnati seventh turned the game into an 8–1 laugher and forced a seventh game. (Courtesy of Chance Brockway.)

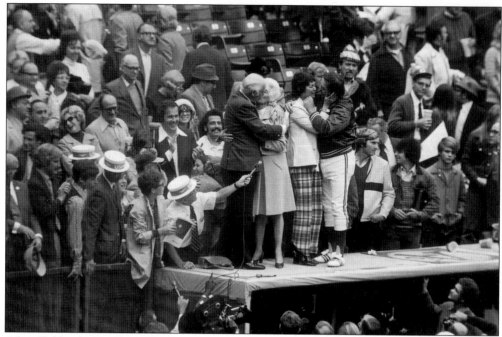

After Oakland won Game Seven 3–2 at Riverfront, A's owner Charlie Finley and manager Dick Williams climbed atop the third base dugout to kiss their wives. The public demonstration didn't please Reds' GM Bob Howsam, who years later told Reds' historian Greg Rhodes that the kissing scene "stuck in his craw." The Reds would get their revenge against Oakland in the fall of 1990. (Courtesy of Jack Klumpe/ Road West.)

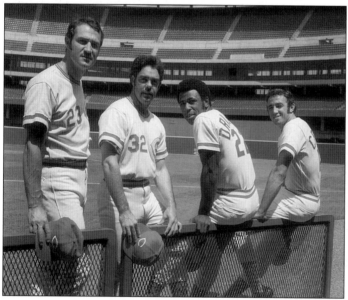

These were four new faces for 1973 at Riverfront. Outfielder Andy Kosco (far left) came to town right before Opening Day in a trade with the Red Sox. He hit .280 for the Reds, 44 points above his career average, with nine home runs in only 118 at bats. Freddie Norman, a short lefthander, was traded to Cincinnati by the San Diego Padres in June and immediately bolstered a faltering pitching staff. He threw shutouts in his first two starts and compiled a 12-6 record on the year for the Reds. Rookie Dan Driessen, who had come up through the farm system, showed promise, batting .301 in 102 games, most of which he played as a third baseman. A backup shortstop acquired from St. Louis, Ed Crosby appeared in only 36 games for the Reds in 1973, his only year with the ballclub. (Courtesy of Jack Klumpe/ Road West.)

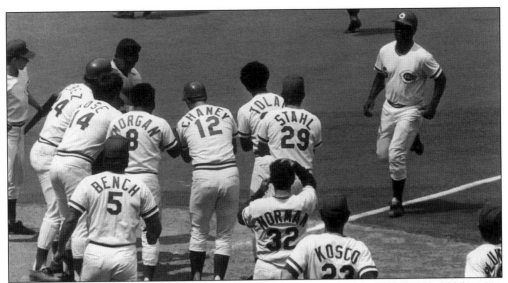

Hal King was near the end of a mediocre career as a backup catcher when he hit one of the most notable home runs in the history of Riverfront Stadium on July 1, 1973. King pinch-hit with two on and two outs in the bottom of the ninth and the Reds trailing the Dodgers 3–1 in the first game of a double-header. Future Hall-of-Famer Don Sutton got ahead of King 2–0, but King hit the next pitch over the right field wall for a walk-off home run. The inspired Reds, who started the day 12 games behind the first-place Dodgers, won the nightcap too (in extra innings) and went on a 60-26 tear to overtake LA and win the Division. King had only 11 hits all year, but four were homers; three were pinch hits, and two were game-winners. (Courtesy of Jack Klumpe/ Road West.)

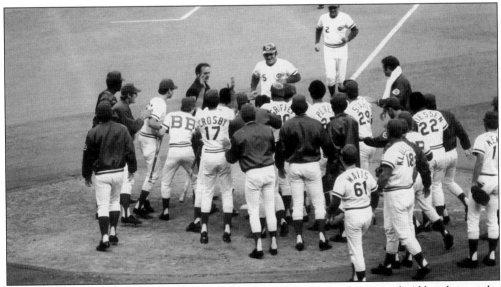

In the 1973 NLCS the Reds (99-63) went up against the New York Mets, who'd barely won the East Division with an unimpressive 82-79 record. The opening game of the series was a pitchers' duel between Jack Billingham and Tom Seaver. The Reds couldn't score against Seaver, who struck out 13, until Pete Rose hit a solo home run in the eighth inning to tie the game 1–1. Then, with one out in the bottom of the ninth, Johnny Bench hit another solo shot off Seaver to give the Reds an exciting 2–1 win. (Courtesy of Jack Klumpe/ Road West.)

Don Gullet started Game Two for the Reds and pitched well, allowing two hits and one run in five innings. The only problem was that Mets' starter Jon Matlack was nearly untouchable. He struck out nine and shut out the Reds on two hits, both by Andy Kosco. The series then shifted to New York, where the Mets won Games Three and Five to cop the National League pennant and advance to the World Series. (Courtesy of Jack Klumpe/ Road West.)

On Opening Day 1974, Hank Aaron takes his first swing of the season and hits the home run that tied him with Babe Ruth for career homers. Aaron's 714th came off Jack Billingham with two on in the first. The Braves led 6-2 after seven and a half, but a three-run homer by Tony Perez in the eighth and an RBI double by Pete Rose in the ninth knotted the score at six. Rose won it for the Reds in the eleventh, scoring from second on a wild pitch. (Courtesy of Jack Klumpe/ Road West.)

Anyone who was the Reds' backup catcher during Johnny Bench's prime simply wasn't going to see a whole lot of playing time. Such was the fate of Bill Plummer, who averaged 128 at bats per year from 1972 through 1977. Plummer's best year was 1976, when he hit .248 with four homers and 19 RBI in 153 at bats. On July 3, 1975, Plummer broke up a no-hitter by the Padres' Randy Jones with an eighth-inning double, the only hit allowed by Jones on the day. (Courtesy of Chance Brockway.)

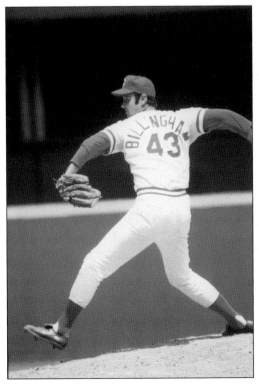

Jack Billingham was one of the Red Big Machine's most dependable starting pitchers. Part of the big trade with Houston, he was with the Reds from 1972 through 1977 and gave the ballclub 200 plus innings four times. He won 19 games for the Reds twice (in 1973 and 1974) and finished his Reds' career 87-63. Billingham pitched in three World Series for the Reds, giving up one earned run in 25 1/3 innings, good for an ERA of 0.36, a record which still stands. (Courtesy of Chance Brockway.)

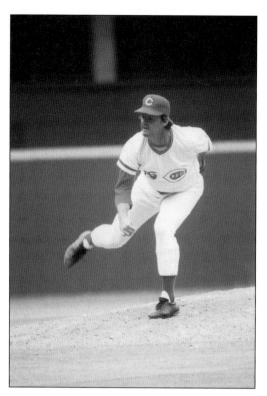

Clay Carroll, traded to the Reds in 1968 by the Atlanta Braves, was a workhorse out of Sparky Anderson's bullpen. Nicknamed "Hawk" for his sharp nose, Carroll made fifty or more appearances for the Reds every year from 1968 through 1975. He won the NL Fireman of the Year Award in 1972 for leading the league in saves with 37 and was twice named to the All-Star team (in 1971 and 1972). Carroll was the winning pitcher in the seventh game of the 1975 World Series, but the Reds traded him to the Chicago White Sox after the season, mainly because of his demand for a two-year contract. At the end of the 2002 season, he ranked third on the Reds' all-time career saves list with 102. (Courtesy of Chance Brockway.)

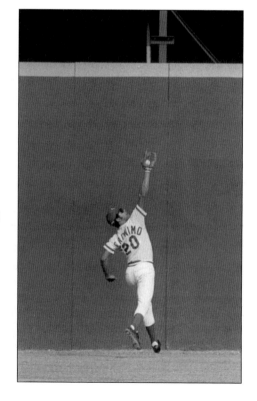

Cesar Geronimo also came to the Reds in the multi-player trade with Houston, and his Gold-Glove play in center field solidified the Big Red Machine's defense. Geronimo was the closest thing to an easy out in the BRM's murderer's row, and he was the only member of the so-called "Great Eight" group of regulars that won the back-to-back World Championships in 1975 and '76 never selected to the National League All-Star team. He was the 3,000th strikeout victim of both Bob Gibson and Nolan Ryan; a dubious honor which prompted him to say: "I just happened to be in the right place at the right time." (Courtesy of Bob bruckner.)

Acquiring outfielder George Foster from the San Francisco Giants in 1971 in exchange for backup shortstop Frank Duffy was one of the best trades ever pulled off by the Reds. Foster came to Cincinnati as a raw, inexperienced player, but he came of age just in time to become a key member of the "Great Eight." Never much of a glove in left field, Foster became a feared slugger. He led the team in home runs six consecutive years (1976-81), and his total of 244 homers as a Red places him fifth on the team's all-time list. (Courtesy of Chance Brockway.)

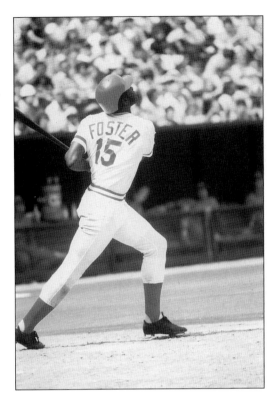

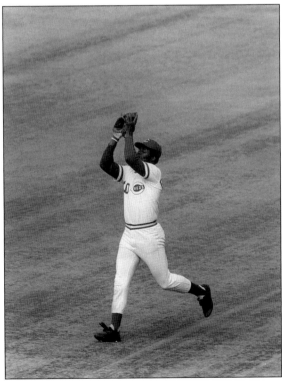

The regular right fielder during the heyday of the Big Red Machine was Ken Griffey, whom the Reds signed out of Donora, Pennsylvania, the hometown of Hall-of-Famer Stan Musial. Griffey hit .384 during a late-season trial (25 games) in 1973; struggled in 1974; and became a regular in 1975. He hit over .300 five times for the Reds, with a high of .336 in 1976, and was a constant base stealing threat at the top of the Reds' lineup (against righthanded starters). He went to the Yankees as a free agent in 1982 and later played for Atlanta before returning to the Reds at the end of 1988. After being released by the Reds in 1990, he joined the Seattle Mariners and played in the same outfield with his son, Ken Griffey, Jr. (Courtesy of Bob Bruckner.)

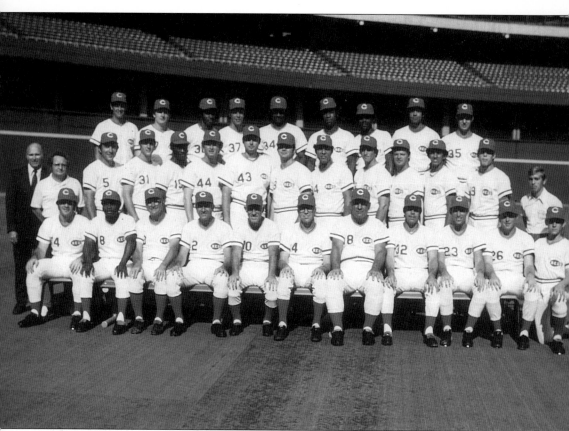

This is the team picture of the 1975 World Champion Cincinnati Reds. From left to right: (first row) Pete Rose, Joe Morgan, Coach George Scherger, Coach Alex Grammas, Manager Sparky Anderson, Coach Larry Shepard, Coach Ted Kluszewski, Fred Norman, Doug Flynn, Merv Rettenmund, and batboy; (second row) Traveling Secretary Paul Campbell, Clubhouse Manager Bernie Stowe, Johnny Bench, Clay Kirby, George Foster, Pat Darcy, Jack Billingham, Gary Nolan, Tony Perez, Bill Plummer, Clay Carroll, Dave Concepcion, Rawly Eastwick, and Trainer Larry Starr; (third row) Darrel Chaney, Terry Crowley, Ken Griffey, Will McEnaney, Pedro Borbon, Dan Driessen, Ed Armbrister, Cesar Geronimo, and Don Gullett. (Courtesy of Jack Klumpe/ Road West.)

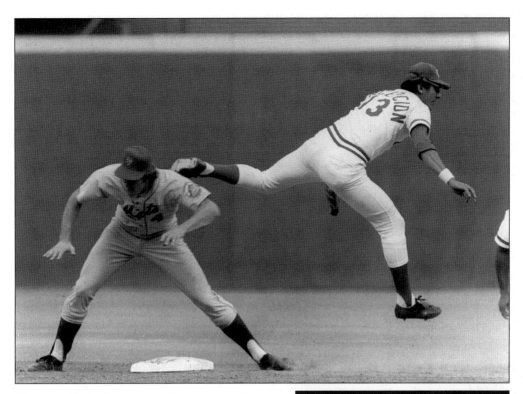

Shortstop Dave Concepcion, leaping over the
Mets' Bruce Boisclair, was a key part of the Big
Red Machine's lauded "strength up the middle"
defense—consisting of catcher Johnny Bench,
Concepcion, second baseman Joe Morgan, and
center fielder Cesar Geronimo. Each member of
this group won the Gold Glove Award for his
position four years in a row (1974-77);
Concepcion won his fifth and final Gold Glove
in 1979. A skinny kid from Aragua, Venezuela,
when he first came up, Concepcion worked hard
to make himself into a competent hitter. When
he hit .301 in 1978, he became the first Reds'
shortstop to reach the .300 level in 65 years. He
finished with a .267 average and 2,326 hits.
(Courtesy of Bob Bruckner.)

Freddie Norman was a small pitcher (5'8", 160)
with a big heart. After spending a decade knocking
around the majors with little success, he found a
home in Cincinnati and became a key member of
the Big Red Machine's starting rotation. With the
BRM's defense and high-octane offense backing
him up Norman won in double figures for seven
consecutive years (1973-79). Altogether, he started
231 games for the Reds and compiled a record of
85-63. (Courtesy of Bob Bruckner.)

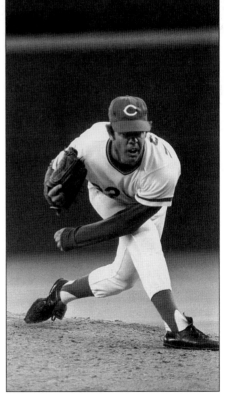

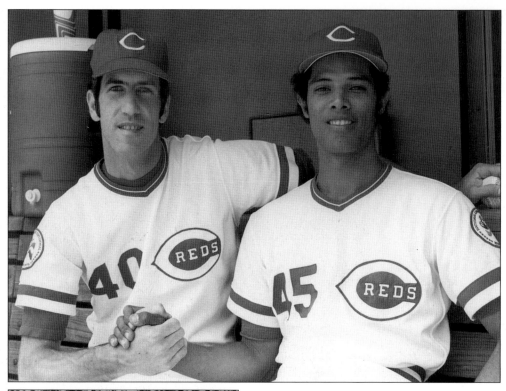

Pitchers Pat Zachary (left) and Manny Sarmiento were rookies in 1976. Zachary was a starter, and his 14-7 record earned him the NL Rookie of the Year Award. After a 3-7 start in 1977 he was traded to the Mets. His 69-67 career record also reflected brief stints with LA and Philly. A reliever from Cagua, Venezuela, Sarmiento went 5-1 in 1976. His best year was 1978 when he appeared in 63 games, won nine games (against seven losses), and recorded five saves. (Courtesy of Bob Bruckner.)

In 1977 outfielder George Foster won the NL MVP Award, giving the Big Red Machine their sixth such award of the decade. Wielding an ebony bat he called "Black Betsy," Foster tore the cover off the ball in '77, as he led the National League in home runs (52), RBI (149), slugging percentage (.631), and runs (124), while batting .320. Foster's 52 combined with Johnny Bench's 31 gave the pair of sluggers the third most homers by a duo in one season in Reds' history. Foster hit 40 homers the next year to lead the NL for the second year in a row. (Courtesy of Bob Bruckner)

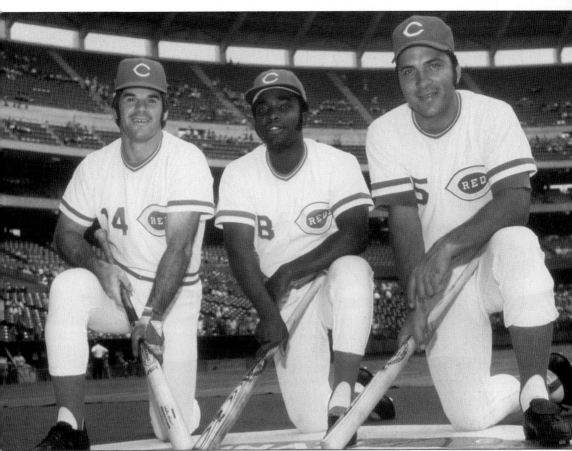

The grouping of this triumvirate was not accidental. Pete Rose (on the left), Joe Morgan, and Johnny Bench were not only three of the greatest players in baseball history, but they also put together an incredible run of National League MVP Awards. From 1970 through 1976, they won five of the seven NL MVPs awarded (Bench won in 1970 and 1972; Rose, in 1973; and Morgan, in 1975 and 1976). The only non-Reds' players to break into their club were Joe Torre of the St. Louis Cardinals in 1971 and Steve Garvey of the Los Angeles Dodgers in 1974. (Courtesy of Chance Brockway.)

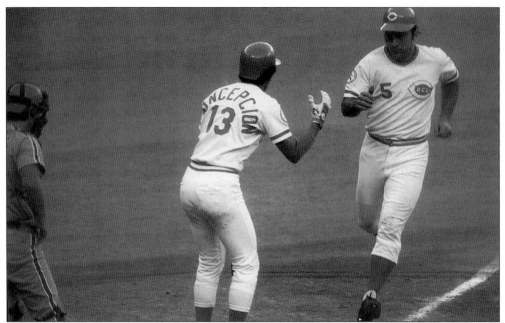

The Reds took the first two games of the 1976 NLCS in Philadelphia and then came home to Riverfront to finish the sweep. They trailed 6–4 entering the bottom of the ninth, but dramatic back-to-back home runs by George Foster and Johnny Bench (being welcomed by Dave Concepcion) to lead off the inning tied the score. A single by Concepcion and two walks set the stage for Ken Griffey, whose infield single off the glove of first baseman and former Red Bobby Tolan won it. (Courtesy of Jack Klumpe/ Road West.)

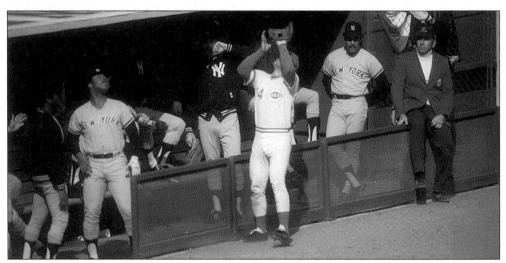

The Reds four-game sweep of the New York Yankees in the 1976 World Series validated their claim of being one of the greatest baseball teams of all time. Joe Morgan's first-inning home run and Johnny Bench's seventh-inning triple were the big blows off the Reds' bats as Cincinnati prevailed 5–1 in Game One at Riverfront. Don Gullet allowed only five hits in 7 2/3 innings to earn the win, while Pedro Borbon held the Yanks hitless the rest of the way. Pete Rose caught Oscar Gamble's popup in front of the New York dugout for the final out of the game. (Courtesy of Jack Klumpe/ Road West.)

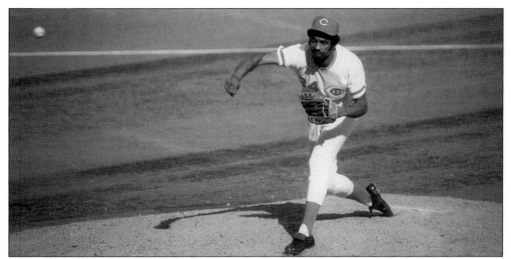

Pedro Borbon, putting the finishing touches on the Reds' Game One victory in the '76 World Series, teamed with Clay Carroll to give Sparky Anderson a terrific one-two punch coming out of the Big Red Machine's bullpen. Always ready to join or start a brawl on the field, the feisty Borbon won in double figures three times for the Reds and pitched in 531 Reds' games, a Cincinnati record. His best year came in 1973 and was highlighted by 11 wins, 14 saves, and a sparkling 2.16 ERA. His son, also named Pedro, pitched in the major leagues in the 1990s with the Atlanta Braves. (Courtesy of Jack Klumpe/ Road West.)

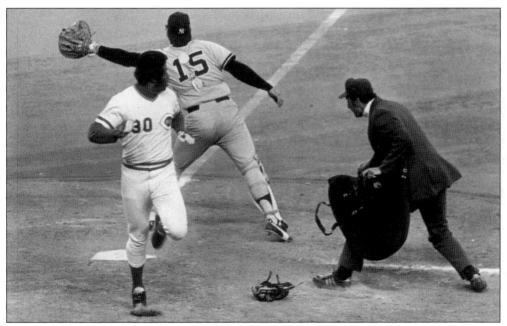

Game Two was tied 3–3 going into the bottom of the ninth. Hall-of-Famer Catfish Hunter retired Dave Concepcion and Pete Rose on routine fly balls, but New York shortstop Fred Stanley threw Ken Griffey's slow grounder into the Reds' dugout, putting Griffey on second base. After Joe Morgan was walked intentionally, Tony Perez lined a single to left. Griffey scampered home with the winning run, as Yankee catcher Thurman Munson reached vainly for left fielder Roy White's tardy throw. (Courtesy of Bob Bruckner.)

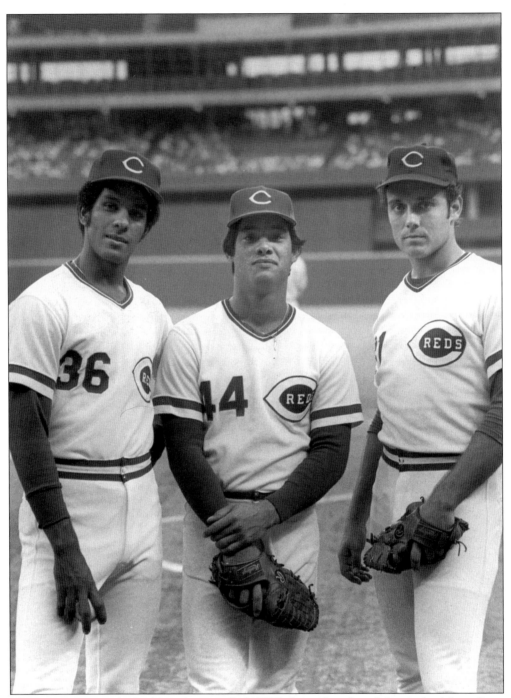

Three new arms on the Reds' pitching staff of 1977 belonged to, from left to right, Mario Soto, Doug Capilla, and Paul Moskau. Capilla, who came in a trade with St. Louis, went 7-8 in 1977, 8-9 overall with the Reds. Moskau, a rookie who went 6-6 in 1977, had a longer career with the Reds than Capilla and compiled a 28-22 record over five years in Cincinnati. Soto, age 21 and also a rookie, went 2-6 in 1977 but later became the ace of the Reds' pitching staff. (Courtesy of Don Cruse.)

Tom Hume, who also debuted in 1977, was an important member of the Reds' bullpen for seven years (1979-85). He put together his best year in 1980 when he was selected (along with Rollie Fingers) as the co-winner of *The Sporting News'* Fireman of the Year Award, for appearing in 78 games, picking up 25 saves, and recording an ERA of 2.56. The Reds' bullpen coach from 1996 through 2002, Hume is tied for fourth place (with Jeff Brantley and Rob Dibble) on the Reds' all-time list of saves leaders, with 88. (Courtesy of Bob Bruckner.)

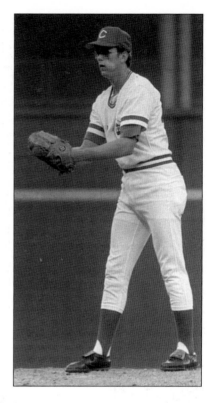

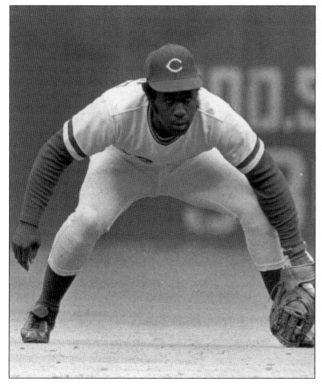

The Reds traded popular, clutch-hitting Tony Perez to the Montreal Expos in December of 1976 in order to give Dan Driessen the chance to play first base regularly (which he did for the next seven and a half years). Driessen, who had struggled as a third baseman, led NL first basemen in fielding percentage three times, but he never hit as the Reds hoped he would. He batted .300 and knocked in 91 runs in 1977, but never approached those numbers again. Driessen's other claim to fame: during the 1976 World Series he became the NL's first designated hitter. (Courtesy of Bob Bruckner.)

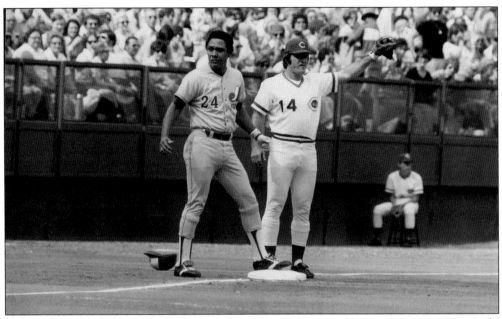

Tony Perez made his return to Riverfront Stadium as a visiting player on June 10, 1977. Reds' fans and players made no attempt to hide their affection for "Doggie" during his homecoming. Here, Perez has advanced to third during the second game of the four-game series and stands next to his old buddy and former teammate Pete Rose. (Courtesy of Jack Klumpe/ Road West.)

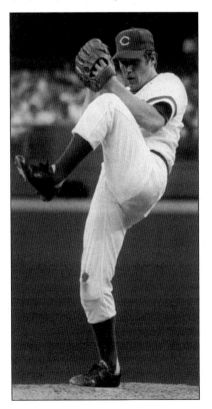

After Tom Seaver began the 1977 season 7-3, the New York Mets traded him to Cincinnati. Seaver went 14-3 for the Reds to give him his fifth 20-win season. "Tom Terrific" slumped to 16-14 in 1978, but on June 16 he pitched a 4–0 no-hitter against St. Louis. It was the first and only no-hitter of his illustrious career and one of four no-hitters ever recorded at Riverfront. Seaver had two more excellent years for the Reds (16-6 in 1979, 14-2 in 1981) before he was traded back to the Mets in late 1982. (Courtesy of Bob Bruckner.)

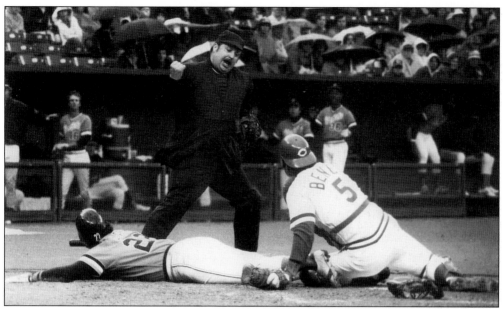

As a catcher, Johnny Bench had no equals. He had cat-like reflexes, huge hands, and an arm so powerful and accurate that it seemed to base stealers as if he were throwing to second base from the pitcher's mound. In short, Bench perfected every aspect of the position he played, including the art of blocking the plate. No one knows how many runners Bench tagged out at the plate during his career, but the number of different photos of him doing exactly that is astonishing. Jack Clark (#22) of the San Francisco Giants, being called out by the umpire, was one of Johnny's many victims. (Courtesy of Bob Bruckner.)

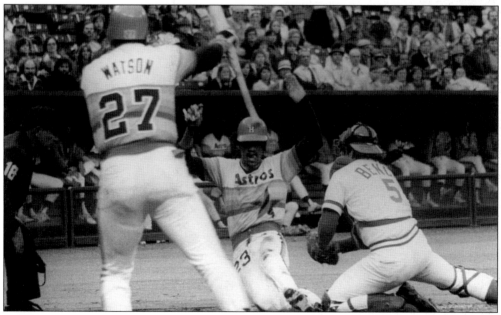

In this photo it appears that Enos Cabell of the Houston Astros is going to slide in past Bench safely. He didn't. Johnny knocked Cabell's foot away from the plate with his shin guard and then slapped the tag on Cabell's leg. (Courtesy of Bob Bruckner.)

Champ Summers (1977-79), whose nickname came from his father, a boxer in the Navy, was a popular Reds' sub with some pop in his bat. On September 12, 1978, he hit a "red seat" home run against Mark Lemongello of Houston, becoming only the third Reds' player to reach the upper deck at Riverfront Stadium and the first to hit a red-seater to right field. George Foster, with six, was the King of the Red Seat Home Run. Altogether, 12 Reds' players turned the trick; the last to do so was Russell Branyan on September 12, 2002. (Courtesy of Bob Bruckner.)

Righthander Bill Bonham, being interviewed in front of his locker at Riverfront, toiled for the hapless Chicago Cubs his entire career (1971-77) before fate dictated that he be allowed to finish up with the Reds (1978-80). Bonham responded with the best year of his career, 11-5, in '78. He won another nine games in 1979 and two more in 1980 to make his composite record in a Reds' uniform 22-13. (Courtesy of Bob Bruckner.)

As he loosens up in the on-deck circle near the visiting dugout, Rick Monday of the Los Angeles Dodgers studies Reds' pitcher Tom Seaver, looking in for his sign. The Dodgers won three of the four NL West Division titles that the Reds did not win in the 1970s, and the packed house at Riverfront for this game testifies to the intense rivalry that developed between the two clubs. (Courtesy of Bob Bruckner.)

On Friday, May 5, 1978, Pete Rose lined a fifth-inning single to left field off Montreal Expos' pitcher Steve Rogers for the 3,000th hit of his career. Rose, age 37, became the 13th player in history to reach the milestone. At this point, Rose was not thinking about breaking Ty Cobb's record or of even reaching 4,000 hits ... at least publicly. He knew the magnitude of his accomplishment in reaching 3,000 hits but revealed that he was equally proud of having surpassed Frankie Frisch's career switch-hitting record of 2,880 hits the previous year. (Courtesy of Jack Klumpe/ Road West.)

As fate would have it, when Pete collected hit number 3,000, Tony Perez was the Montreal first baseman. As the two old friends hugged in celebration, the crowd of 38,000 at Riverfront Stadium gave Rose a five-minute standing ovation. Earlier in the game, Rose had gotten hit number 2,999 on a chopper off the plate. Afterwards, when a reporter asked why he hadn't waited until the next day, Saturday, to pick up his 3,000th hit, Rose said, "Because I didn't want to upstage the Kentucky Derby." (Courtesy of Jack Klumpe/ Road West.)

Johnny Bench warming up in the on-deck circle at Riverfront Stadium was a sight that made many a pitcher weak in the knees. Bench hit three home runs in one game three different times, set the record for career home runs by an NL catcher, and hit more home runs (154) in Riverfront Stadium than any other player. Atlanta Braves' catcher Biff Pocoroba and pitching coach Cloyd Boyer discuss how to pitch to Bench with pitcher Preston Hanna, who seems reluctant to even look in the direction of the Reds' #5. (Courtesy of Bob Bruckner.)

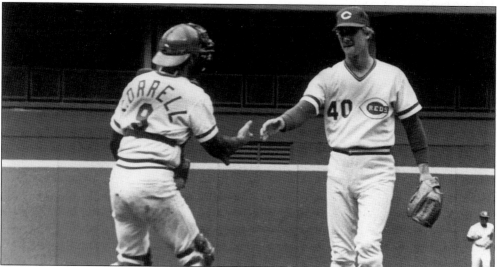

After spending years in the Pittsburgh farm system and one year with the Oakland A's, Doug Bair (being congratulated by Vic Correll) established himself as a major league pitcher with the Reds in 1978. That year Bair won seven games, saved 28, and fashioned an ERA of 1.97. The following year he helped Cincinnati capture the West Division flag by winning 11 and saving 16. He never stayed with one team long after the Reds traded him in 1981, but he lasted until 1990 and retired a winner (55-43). Correll, who spent three years with the Reds (1978-80), batted .229 in his 410-game major league career. (Courtesy of Bob Bruckner.)

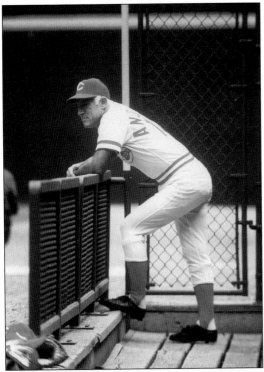

The second-place finishes of 1977 and 1978 were deemed unacceptable for the Big Red Machine, and it was manager Sparky Anderson who took the fall. His firing, a black day in Reds' history, happened on November 28, 1978, six days after the Reds returned from a good will trip to Japan. Anderson, who never said a negative word about the organization, moved on to the Detroit Tigers and won another World Championship with them in 1984. He remains the greatest manager in Reds' history, ranking first in wins (863, against 586 losses) and winning percentage (.596). He was elected to the Baseball Hall of Fame in 2000. (Courtesy of Chance Brockway.)

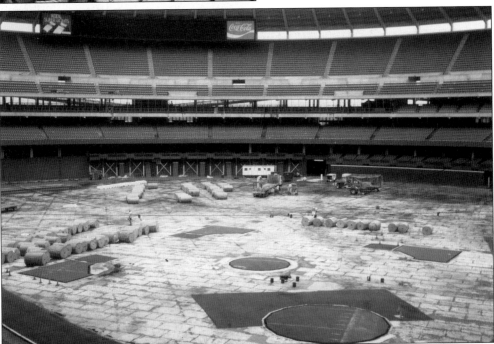

On March 1, 1979, Riverfront Stadium was in the midst of having its artificial turf replaced. The skin areas of the field (the mound, home plate, and the area around the three bases) are covered with blankets of the old turf being replaced. The artificial turf was also replaced before the 1988 and 1997 seasons. (Courtesy of Visual History Gallery.)

Before he won the MVP Award of the 1986 World Series for leading the New York Mets to a seven-game victory over the Boston Red Sox, Ray Knight was known for being married to golfer Nancy Lopez and for being the player designated to replace Pete Rose as the third baseman of the Cincinnati Reds in 1979. The pugnacious Knight took full advantage of his first starting job, hitting .318 (third best in the NL), for which he was named the Reds' MVP. He played two more years in Cincinnati before he was traded to Houston. After finishing his career in the American League, he became a broadcaster for ESPN and a coach for the Reds. He managed the Reds to an 81-81 record in 1996 and was replaced by Jack McKeon in July of the '97 season. (Courtesy of Chance Brockway.)

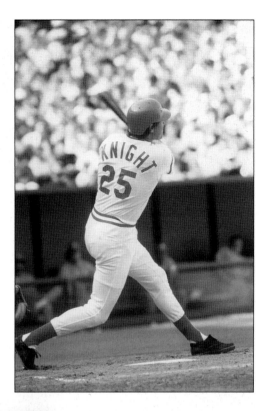

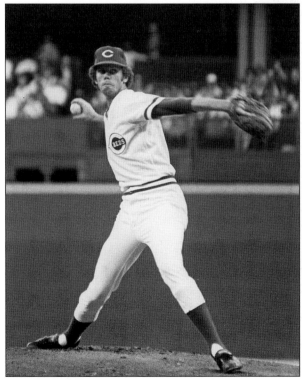

Mike LaCoss, a lanky, frizzy-haired 22-year-old starting pitcher, went 4-8 for the Reds in his rookie season of 1978. The next year he started out 8-0 and made the NL All-Star team. He finished the season with a 14-8 slate, which turned out to be the best of his career. He won another 14 games for the Reds in 1980-81 before being traded to Houston. He also pitched for Kansas City and San Francisco and finished with a 98-103 career record. (Courtesy of *Reds Report*.)

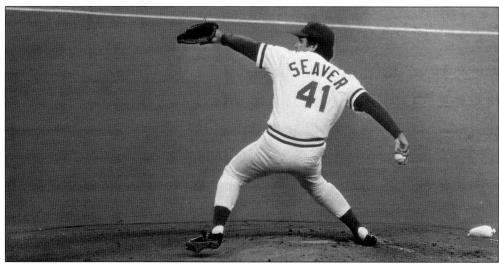

By winning the West Division in 1979 the Big Red Machine advanced to post-season play for the seventh time in the decade. Unfortunately, the Reds were swept by the Pittsburgh Pirates, Cincinnati's patsies in 1970, '72, and '75. Tom Seaver started Game One at Riverfront and left after eight innings with the game tied 2–2. A three-run homer by Willie Stargell in the top of the 11th decided the contest. Game Two, another extra-innings win for Pittsburgh, wasted more good Reds' pitching, this time by Frank Pastore. (Courtesy of Jack Klumpe/ Road West.)

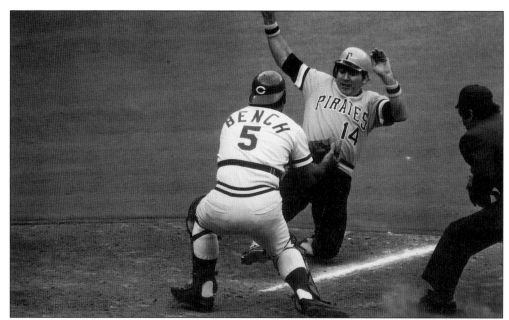

In his next-to-last year of full-time catching, Johnny Bench still blocked the plate like a brick wall, as Ed Ott of the Pirates discovered during the 1979 NLCS. The Reds' loss to the Pirates was attributable to a lack of hitting. In a pale imitation of the Big Red Machine in their heyday, the club scored a total of five runs in the three games. Dave Concepcion (with six hits) and Dave Collins (with five) were the leaders, and Johnny Bench homered to prevent the Reds from being shut out in the finale. The home run was Bench's 10th and final in post-season play. (Courtesy of Jack Klumpe/ Road West.)

FOUR

Celebrations, Diversions, and Class Acts

Because of what happened on the field, Riverfront Stadium was a place where excellence and high achievement were often celebrated. Over the Stadium's 32-year history, Reds' fans witnessed many ceremonies that recognized the accomplishments of championship Reds' teams and of individual players who won awards or reached significant milestones. Two of the most popular ceremonies were those that retired the uniform numbers of great players and those that inducted new members into the Reds' Hall of Fame. Appropriately, the Stadium itself was the focus of celebration on the night it opened in 1970, and throughout its final season in 2002 the Reds paid tribute to Riverfront in various ways.

As entertaining as the play on the diamond was, it didn't provide all the fun to be had at Riverfront Stadium. For starters, there was Opening Day and the traditional pre-game Findlay Market Parade through downtown Cincinnati. Much more than just the first game of the season, Opening Day at Riverfront was a gigantic party and holiday extravaganza which signaled that Reds' fans had made it through another winter. The Reds also sponsored numerous special events, such as Fan Appreciation Day, College Night (when discounted tickets were available to college students), and post-game concerts, featuring such musical attractions as the Beach Boys and Christian artist Michael W. Smith. As for collectors, they were supplied with a steady stream of Reds' give-away items at Riverfront. The list of freebies included, but was hardly limited to: posters, calendars, magnetic schedules, team pictures, baseball cards, umbrellas, caps and hats of all kinds, pins, beanie babies, and bobbing head dolls. And then there were those unscripted "moments" that also became unforgettable memories: e.g., the time a swarm of 10,000 bees occupied the visitors' dugout and the box seats, interrupting a nationally televised game; the time Nolan Ryan imitated the "psycho"-antics of Brad "The Animal" Lesley after striking out a Reds' batter; and the time manager Lou Piniella, upset over an umpire's decision, picked up the first base bag and hurled it into right field.

Finally, Riverfront Stadium was the office where a lot of good people who weren't ballplayers worked. Some of them labored anonymously behind the scenes, while others became as famous and recognizable as the players. In both cases, the efforts of such professionals helped make the Riverfront Stadium experience for Reds' fans the joy that it was.

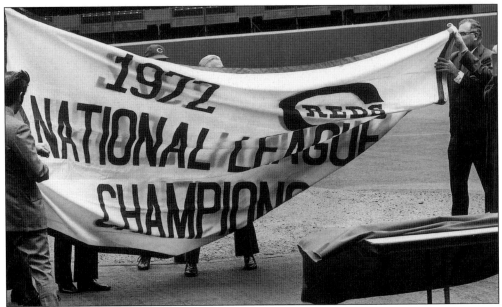

One of the first orders of business for 1973, which the Reds took care of on April 8, three days after Opening Day, was the unfurling and presentation of the National League pennant the team had won the year before. This was a ceremony Reds fans witnessed frequently during the decade (1970-79) that belonged to the Big Red Machine. (Courtesy of Jack Klumpe/Road West.)

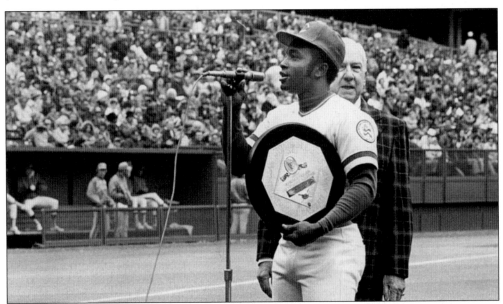

Awards ceremonies were also common at Riverfront Stadium during the 1970s. In this picture, Joe Morgan accepts his National League Most Valuable Player Award for 1975, as former NL President Warren C. Giles looks on. Morgan won the award again in 1976. During the decade Reds' players also won four other NL MVP Awards, 25 Gold Gloves, three NL Fireman of the Year Awards, two World Series MVP Awards (Rose in '75, Bench in '76), and two Manager of the Year Awards (Sparky Anderson in '72 and '75). In addition, Reds' players earned 52 spots on NL All-Star teams during the '70s. (Courtesy of *Reds Report*.)

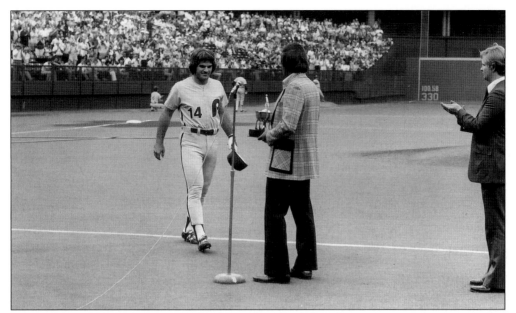

In December of 1978, Pete Rose walked away from his beloved Cincinnati Reds, signing a free agent contract to play for the Philadelphia Phillies. On June 1, 1979, he made his return to Riverfront Stadium for the first time as a visiting player. Ironically, he was presented before the game with the Reds' Most Valuable Player trophy for 1978. The crowd of 48,968 gave Rose yet another standing ovation. (Courtesy of Jack Klumpe/ Road West.)

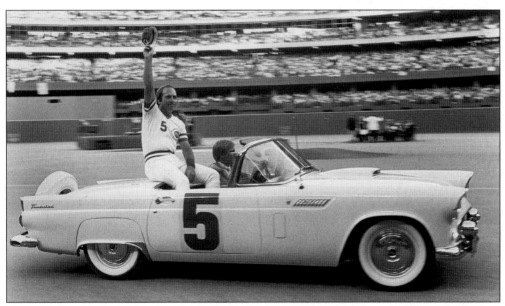

No one who was there will ever forget September 17, 1983, at Riverfront Stadium. A huge and emotional crowd showed up for Johnny Bench Night to say goodbye and thank-you to one of the most beloved players in Reds' history. Marty Brennaman once said that when it came to having a flair for the dramatic, no other player he ever saw came close to Johnny Bench. Case in point: Bench thrilled the crowd by hitting a home run in the game, the 389th and last of his career. He also caught a few innings, something he did only five times all year. (Courtesy of *Reds Report*.)

This red Corvette was not the only automobile ever given to a Reds' player, but it is probably the most famous. The car was given to Pete Rose by the Chevrolet dealers of Cincinnati in honor of his breaking Ty Cobb's record for career base hits, and it was driven onto the field during the lengthy ceremonies following the historic base knock on September 11, 1985. Ironically, the car was not cherished by Rose, who already owned more expensive, more exotic sports cars. Rose sold the Corvette to a well-to-do Cincinnati sports fan, who made the car the centerpiece of his sports memorabilia retail store. (Courtesy of Don Cruse.)

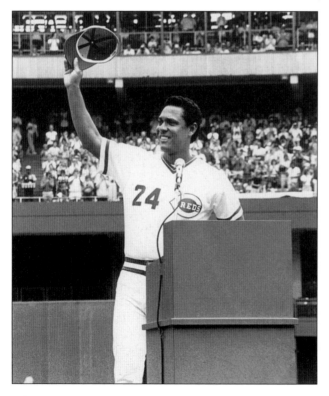

On September 21, 1986, the Reds honored Tony Perez, who was retiring at the end of the season. It took the sportswriters a while to vote Perez into the Baseball Hall of Fame, but Reds' fans never underestimated his contributions to the success of the Big Red Machine. "Doggie" started for the Reds at first base on Tony Perez Day and hit a single in two times at bat. On October 4, Perez hit his 379th and last home run, which at the time tied him with Orlando Cepeda for most homers by a Latin player. (Courtesy of *Reds Report.*)

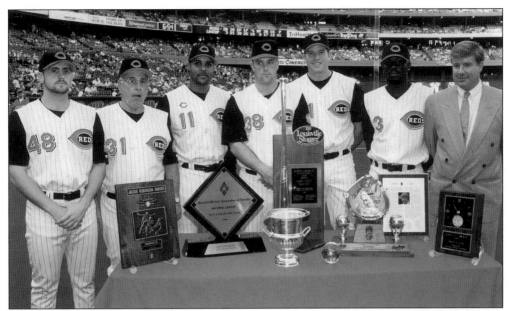

In 1999 the Reds lost a one-game playoff with the New York Mets for the NL Wild Card spot, but the team's 96 victories were the most for a Cincinnati club since 1976. Early in 2000 the team had a lot of hardware to show off for its efforts the previous year. From left to right are Scott Williamson (Jackie Robinson Rookie of the Year Award), Jack McKeon (Manager of the Year), Barry Larkin (Louisville Silver Slugger Award, his ninth), Pete Harnisch (Johnny Vander Meer Award for Reds' outstanding pitcher), Sean Casey (Hutch Award), Pokey Reese (Rawlings Gold Glove Award), and GM Jim Bowden (NL Executive of the Year Awards). (Courtesy of *Reds Report*.)

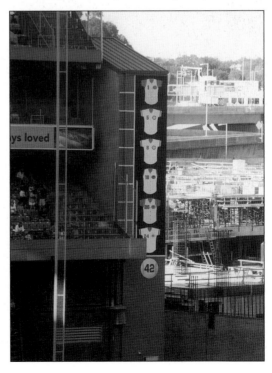

Under the leadership of Chief Operating Officer John Allen, the Reds made a renewed effort in the latter half of the 1990s to celebrate the team's glorious past. Part of this effort was devoted to retiring and displaying the jerseys of great Reds. The retired jerseys of former manager Fred Hutchinson (#1) and Johnny Bench (#5) went up on the outfield wall in September of 1996. During the 1998 season, the jerseys of Joe Morgan (#8), Frank Robinson (#20), and Ted Kluszewski (#18) were retired, and in 2000 Tony Perez (#24) joined this exclusive club. After the "bite" was taken out of Riverfront Stadium, the six retired jerseys were mounted to the facing of an elevator shaft on the edge of the left field grandstands in a vertical display. (Courtesy of *Reds Report*.)

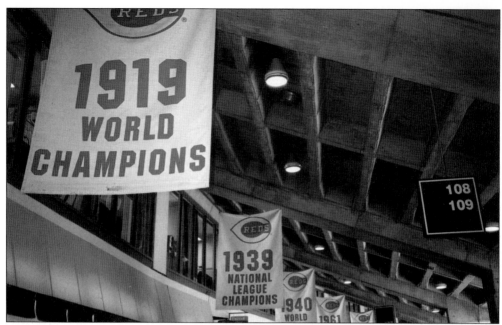

To celebrate the Reds' championship teams a series of championship flags were hung from the ceiling above the field level concourse. The flags honored the World Champions of 1919, 1940, 1975, 1976, and 1990, and the National League Champions of 1939, 1961, 1970, and 1972. (Courtesy of Rick Block.)

The Big Red Machine was feared around the National League, but when they played their wives they were always the underdogs. Here Mrs. Phil Gagliano uses a technique not taught in spring training camps to keep Darrel Chaney from getting too big a lead off second base. Mrs. Andy Kosco (#23) is stationed in left field. (Courtesy of Jack Klumpe/ Road West.)

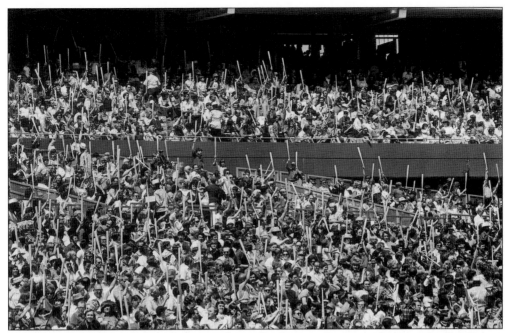

In the good old days, Little Leaguers used wooden bats, just as major leaguers do. Bat Day at Riverfront Stadium was always good for a sellout crowd, as this shot of the Green (top) and Blue (bottom) levels on April 29, 1973, indicates. (Courtesy of Jack Klumpe/ Road West.)

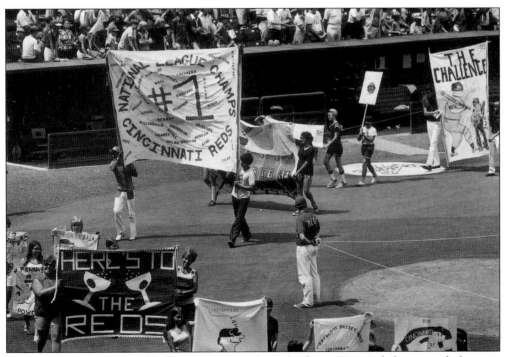

Banner Day was another fan favorite at Riverfront Stadium. Fans with home-made banners saluting the Reds got to go onto the field and march around the Stadium. (Courtesy of Jack Klumpe/ Road West.)

The Reds celebrated numerous milestones and special events at Riverfront. When the occasion called for it, such as Opening Day 1990, even the hard-working grounds crew knew how to go formal. (Courtesy of *Reds Report*.)

To recognize the importance of agriculture and husbandry throughout Reds' country, the Reds sponsored Farmer's Night for many years at Riverfront. At these special events, fans saw Reds' players compete in cow-milking, egg tossing (and catching), and wheel barrow racing (while blindfolded) contests. (Courtesy of Bob Bruckner.)

Fans have always been crazy about autographs, and there was always a chance of getting some free ones at Riverfront . . . even from the Reds' superstars. Here a group of autograph collectors in the blue seats, kids and adults alike, show their eagerness to have Johnny Bench sign their scorecards, programs, and baseballs. (Courtesy of Chance Brockway.)

Compared to the Famous Chicken and the Philly Phanatic, "Mr. Red" was a very mild-mannered, some would say, "unentertaining" mascot. Perhaps that is why management withdrew Mr. Red from the scene for a while. Nevertheless, youngsters, such as Cesar Geronimo's son, got a kick out of him. When Marge Schott became general partner of the club, she tried to promote Schottzie, her beloved St. Bernard, as the team's official mascot, but the public never embraced the idea. (Courtesy of Bob Bruckner.)

It's a long season, and baseball players can't always be serious. Relief pitcher Pedro Borbon was one of the loosest characters on the Big Red Machine. Here is Pedro in the Reds' clubhouse at Riverfront, giving his teammates his impression of a motorcycle cop in the batter's box. When he was traded to the San Francisco Giants, Borbon put a voodoo curse on the Reds and Riverfront Stadium. (Courtesy of Bob Bruckner.)

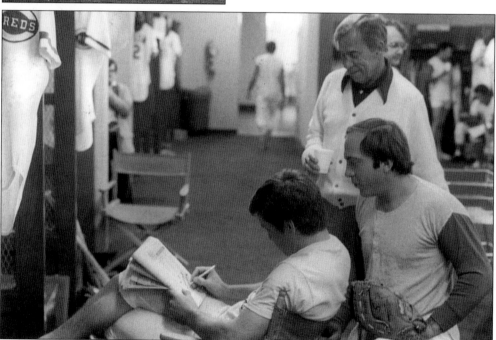

Hall of Famer Tom Seaver had less comical ways of relaxing in the clubhouse than Borbon…like working a newspaper crossword puzzle in front of his locker. Johnny Bench and former Brooklyn Dodgers shortstop Pee Wee Reese (also a Hall of Famer) are ready to help if Tom gets stuck. (Courtesy of Bob Bruckner.)

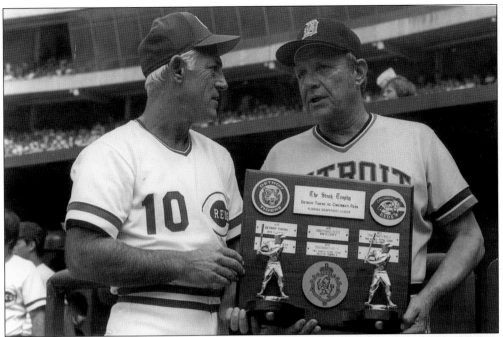

The Reds have always been a generous supporter of Knot Hole Baseball, the primary baseball program for youngsters in Cincinnati. For years the Reds played an exhibition, the Kid Glove Game, at Riverfront and gave the proceeds to Knot Hole Baseball. Before the 1977 Kid Glove Game between the Reds and the Detroit Tigers, Detroit manager Ralph Houk gives Sparky Anderson a trophy the Reds earned earlier that spring for defeating the Tigers in Florida Grapefruit League games. (Courtesy of Bob Bruckner.)

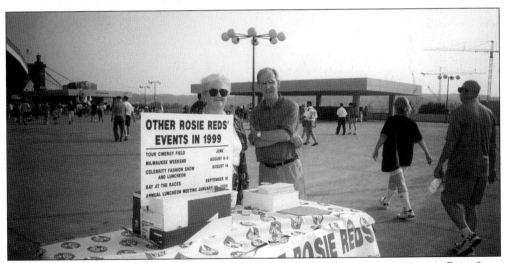

The Rosie Reds, seen here recruiting on the plaza, were always a presence at Riverfront Stadium. Although the organization started out in 1963 as a women's booster club, "Rosie" is an acronym (Rooters Organized to Stimulate Interest and Enthusiasm in the Cincinnati Reds) meant to indicate that men are eligible for membership as well. One of the Rosie Reds' philanthropic efforts is the endowment of a baseball scholarship at seven different Cincinnati-area colleges. (Courtesy of Joann Spiess.)

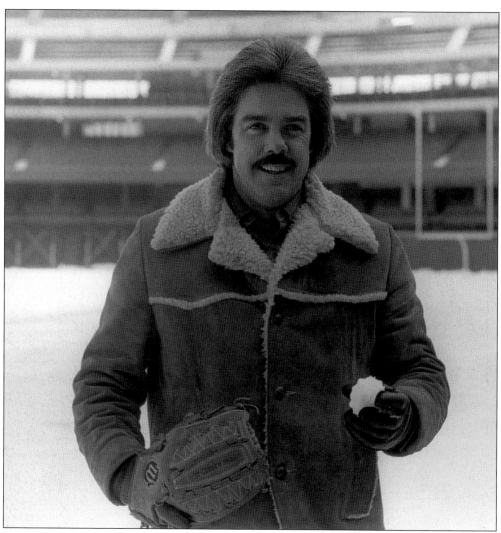

Pitcher Freddie Norman loved baseball so much that he showed up at Riverfront in the dead of winter, wearing three gloves and ready to throw frozen heat past any snowman intrepid enough to bat against him. Notice the football goal post over Norman's left shoulder. (Courtesy of Bob Brucker.)

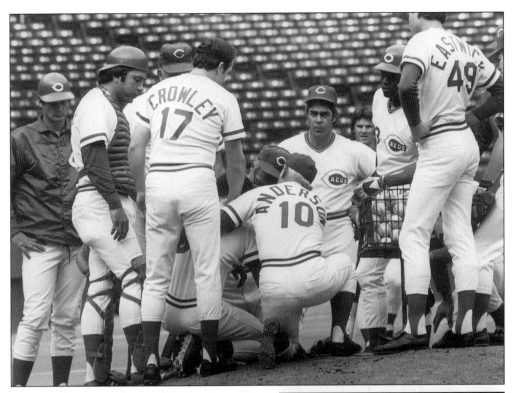

Of course, it wasn't always fun and games at Riverfront. Bad things—especially injuries—sometimes happened. In 1973 Dave Concepcion broke his ankle sliding into third base, and eight years later Johnny Bench broke his ankle sliding into second. Pedro Borbon wasn't seriously hurt when he was struck by a batted ball during batting practice, but his Big Red Machine teammates and manager Sparky Anderson were concerned about him. The worse thing that ever happened at Riverfront occurred on Opening Day 1996, when home plate umpire John McSherry died of a heart attack on the field seven pitches into the game. (Courtesy of Bob Bruckner.)

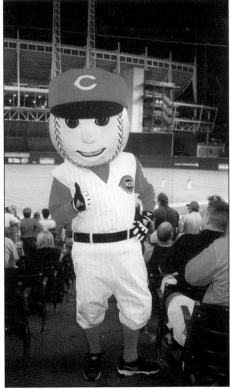

You can't keep a good man—or mascot—down, as the saying goes, and so it was inevitable that Mr. Red would return to Riverfront. Here is our hero with a face-lift, his uniform updated, stationed in the blue seats during the final season, showing us his "The-Reds-can-do-it" spirit. (Courtesy of Rick Block.)

Over the years, none of the notable sportswriters who covered the Reds on a regular basis watched more games at Riverfront than the *Dayton Daily News'* Hal McCoy, the dean of the Reds' press box and the Chairman of the Cincinnati Chapter of the Baseball Writers Association of America for the 2002 season. Genial and witty, the cigar-chomping McCoy had the complete trust of the players and was known for scooping the competition. One of his favorite Riverfront Stadium memories came on June 23, 1971, before he became the Reds' beat man for the *Daily News*. The newspaper's regular reporter who'd never seen a no-hitter wanted a night off, so McCoy went in his place and wound up covering the game during which Philadelphia Phillies' pitcher Rick Wise pitched a no-hitter *and* hit two home runs. (Courtesy of Hal McCoy.)

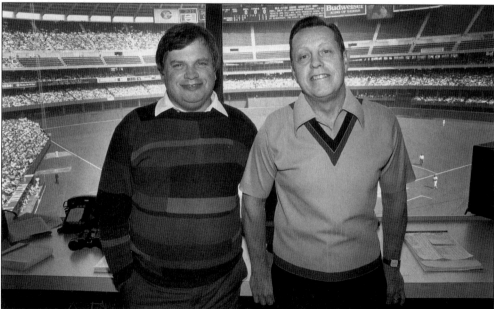

One of the first non-sportswriters to serve as an official scorer in the major leagues, Glenn Sample (on the right) held that post at Riverfront Stadium with distinction from 1980 through 2002. Sample played the game in his youth with future major league managers Don Zimmer and Jim Frey and later coached the University of Cincinnati baseball team for 23 years. Eminently qualified, he nevertheless quickly realized that things were different on the major league level: "When you're booed by 55,000 people, and you're right…that's when you realize this job is not going to be as easy as it looks." Standing next to Sample is Ron Roth, the backup scorer, who filled in for Glenn 10 or 11 times per year. (Courtesy of *Reds Report*.)

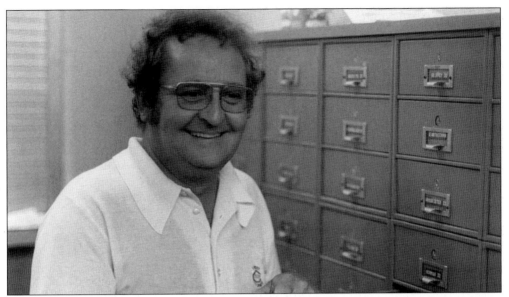

Another consummate professional was Senior Clubhouse and Equipment Manager Bernie Stowe, whose career with the Reds spanned the entire history of Riverfront Stadium. Stowe started with the Reds as a batboy in 1947 and worked his way up to equipment manager in 1968. Stowe loved his job, had the respect and affection of the players, and was friendly and courteous to all. He was a big shot to everybody but himself, and he never "big-timed" anybody. His sons Mark and Rick followed in his footsteps; Mark as the visiting clubhouse manager at Riverfront, Rick as the Reds' clubhouse manager. (Courtesy of Bob Bruckner.)

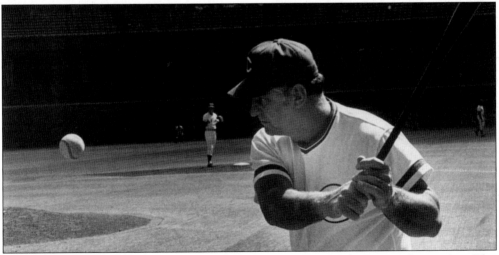

From 1970 to '78 Ted Kluszewski served as the Reds' hitting coach. Famous for cutting off his jersey sleeves which were too tight for his bulging biceps, "Big Klu" was a gentle giant and the most popular Reds' player of the 1950s. An All-American end on the University of Indiana football team, he was discovered by accident when the Reds trained in Bloomington during the war. For helping prepare the baseball diamond, the Reds let Kluszewski take batting practice. Stunned at how far he hit the ball, they immediately offered him a contract. With the Reds he hit 40 or more home runs three consecutive seasons, and 251 of his 279 career homers came in a Cincinnati uniform. (Courtesy of Bob Bruckner.)

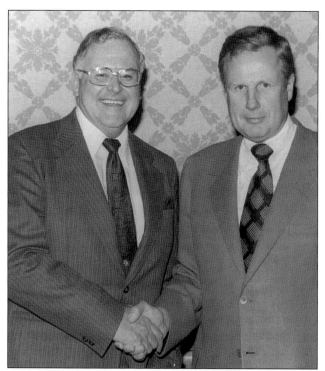

Hired as the Reds' general manager in 1967, Bob Howsam (left) was the architect of the Big Red Machine. He hired Sparky Anderson, engineered the big trade with Houston that brought Joe Morgan to Cincinnati, had a major influence on the design of Riverfront Stadium, and assembled a team to take advantage of the Stadium's artificial surface. A bad back and his disenchantment with free agency led him to resign in 1978, and he turned the team over to his right-hand man, Dick Wagner (right). Wagner, who had none of the people or public relations skills of his former boss, did not fare well and was fired in July of 1983. His replacement: Bob Howsam. (Courtesy of Bob Bruckner.)

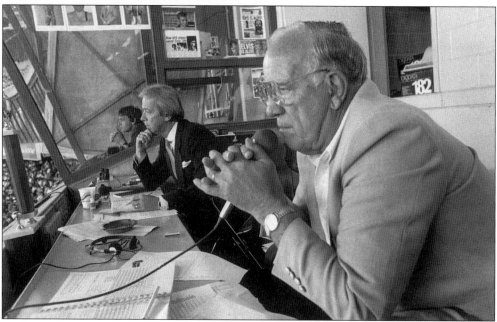

Radio broadcasters Joe Nuxhall (foreground) and Marty Brennaman were as big a part of Reds' baseball at Riverfront Stadium as any players. Their partnership began in 1974 when the Reds hired Brennaman, and Riverfront's final season was their 28th year on the air together. Reds' fans loved them for their knowledge, candor, and humor, and both developed famous signatures: "And this one belongs to the Reds!" (Brennaman) and "This is the old lefthander rounding third and heading for home" (Nuxhall). (Courtesy of *Reds Report*.)

FIVE
A Disappointing Decade

The Reds failed to win a divisional flag in the 1980s, and that disappointment, coupled with front office instability and controversies involving Pete Rose, owner Marge Schott, and hotheaded pitcher Rob Dibble, made quite a contrast to the glories of the previous decade. As the decade started, four regulars of the Big Red Machine (Bench, Concepcion, Foster, and Griffey) remained with the club; however, Bench was nearing the end of his career, and Foster and Griffey both left Cincinnati after the 1981 season. After a third-place finish in 1980, the Reds played good baseball in 1981 and actually finished with the best composite record in baseball; but a players' strike split the season in two, and Cincinnati was denied a place in the postseason playoffs because the club failed to win either of the two halves of the season.

In 1982 the team hit bottom, as it set a club record for losses. Highly touted prospects out of the Reds' farm system failed to come through, and an anemic offense led to a 61-101 record and Cincinnati's first last-place finish since 1937. Halfway through the season Russ Nixon replaced John McNamara as manager; while Nixon was replaced by Vern Rapp after the Reds finished last again in 1983, despite improving their record by 13 games.

The bleakness at Riverfront continued unabated in 1984 (when the Reds finished fifth) until the return of Pete Rose as player-manager in August excited Reds' fans and lifted their hopes. Rose's successful pursuit of the career hits record in 1985 put the Reds and Riverfront back in the national spotlight, and under Rose's guidance Cincinnati became competitive again. The Reds finished in second place four years in a row (1985-1988) and might have won the division in 1989 (instead of finishing fifth) had Rose's suspension not distracted them. Other than Rose's history-making 4,192nd hit, the highlight of the decade at Riverfront was Tom Browning's perfect game on September 16, 1988, only the 12th such performance in history. Despite the Reds' failure to win a single flag, the decade was brightened by the stellar performances of Mario Soto, Dave Parker, and John Franco; while those of youngsters Eric Davis, Paul O'Neill, Barry Larkin, and Chris Sabo promised a better future.

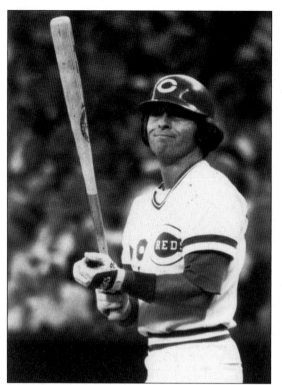

Dave Collins was a speedy switch-hitting outfielder the Reds acquired at the end of 1977 from the Seattle Mariners. Collins didn't play much in 1978, but injuries to George Foster and Ken Griffey gave him a chance to play regularly in 1979, and he made the most of it; hitting a career-high .318 in almost 400 at bats and helping the Reds win the West Division. The next year he played even more, hit .303, and stole 79 bases, the third highest total in Reds' history. After dropping to .272 in 1981, he became a free agent and signed with the New York Yankees. He bounced around the American League for five years, and then returned to the Reds for a three-year stint (1987-89) as a reserve. He was a member of the Reds' coaching staff in 1999-2000. (Courtesy of Bob Bruckner.)

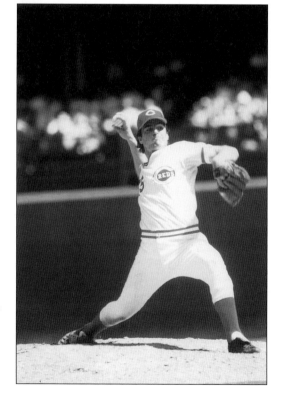

Frank Pastore is remembered for his scintillating performance on Opening Day 1980: a three-hit shutout of the Atlanta Braves, which was the first Opening Day shutout by a Reds' pitcher in 37 years. A last-minute replacement for Tom Seaver, who'd come down with the flu, Pastore went on to enjoy the best season of his career, posting a 3.27 ERA and a team-high 13 wins (against seven losses). Pastore was an important member of the Reds' starting rotation from 1980 through 1984, and his seven-year career record with the club was 45-57. (Courtesy of Chance Brockway.)

Hired in November of 1978, John Francis McNamara had the unenviable task of following in the footsteps of Sparky Anderson. A minor league catcher who never played in the majors, McNamara led the Reds to a West Division title in 1979 and to the best record in baseball in the strike-marred season of 1981. In 1982 he became the scapegoat when years of player losses due to poor management and cost-cutting caught up with the Reds, and he was fired on July 21 with the Reds (34-58) buried in last place. Only Anderson and Pete Rose won more games at Riverfront than "Mac," and his 279 wins (against 244 losses) rank 10th among Reds' managers all-time. (Courtesy of Bob Bruckner.)

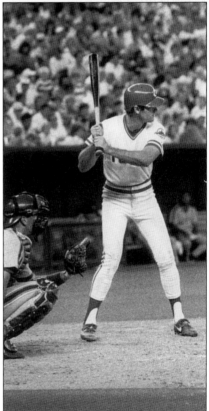

Ron Oester (1978-90), a graduate of Cincinnati's Withrow High School where he earned All-State honors in baseball, realized his dream of playing for the Reds and being managed by his childhood hero, Pete Rose. A switch-hitting second baseman, Oester was a steady, fundamentally sound player who, like his hero, always hustled. A regular from 1982 through 1986, Oester spent his entire 13-year career with the Reds and enjoyed his best year at the plate in 1985, when he hit .295. Only an 0 for 15 start prevented him from batting .300 for the season. (Courtesy of *Reds Report*.)

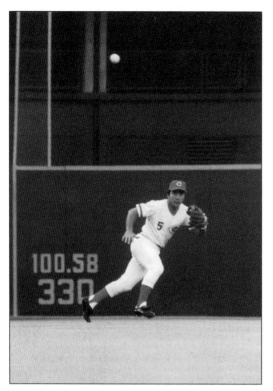

Beginning in 1970, Johnny Bench always played a few games at positions other than catcher (outfield, first base, third base) in order to get some relief from the wear and tear of catching. By 1981 Bench was no longer primarily a catcher. In 1982 he manned the hot corner for 107 games, the most games he ever played in a season at one position other than catcher. (Courtesy of Don Cruse.)

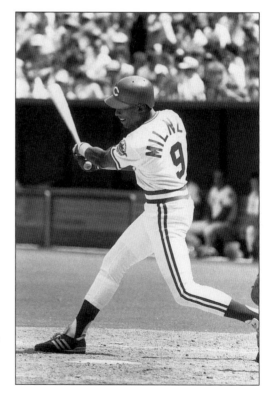

Eddie Milner was a regular in the Reds' outfield from 1982 through 1986. His best year at the plate came in 1986 when he hit .259 with 15 homers and 47 RBI. He was traded to San Francisco before the 1987 season for three pitchers, but came back to the Reds in 1988 for the final 23 games of his career. As a Red he stole 135 bases (and was caught stealing 63 times). After retiring, he played Men's Senior League baseball (for amateurs 30 years of age and older) in the Cincinnati area. (Courtesy of *Reds Report*.)

After getting his feet wet in 20 end-of-the-season games the year before, young Gary Redus found himself in the Reds' starting lineup at Riverfront on Opening Day 1983. He helped the Reds to a win over the Braves by hitting a home run and making a great catch while crashing into the left field wall. Redus tantalized the Reds with his power and speed, but he didn't hit enough to keep his job. After leading the Reds in stolen bases in 1984 and 1985, he was traded with Tom Hume to the Philadelphia Phillies for pitchers Jeff Gray and John Denny. He later played for the White Sox, Pirates, and Rangers and finished his career with nearly as many stolen bases (322) as RBI (352). (Courtesy of Chance Brockway.)

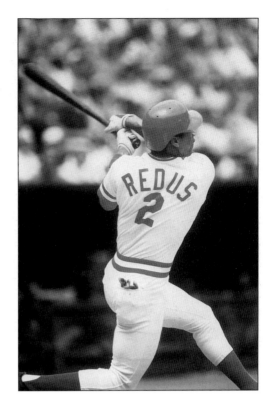

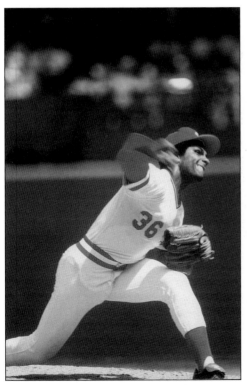

Dominican Mario Soto was basically a two-pitch pitcher, throwing a blazing fastball and a devastating change-up. He was the ace of the Reds' rotation from 1981 through '85, when he won 12, 14, 17, 18, and 12 games, respectively. He led the team in strikeouts six consecutive years (1980-85), struck out more than 200 batters three times (with a high of 274 in '82), made the NL All-Star team three times, and finished his 12-year career (all with the Reds) with exactly 100 victories (against 92 defeats). He was inducted into the Reds' Hall of Fame in 2001. (Courtesy of Chance Brockway.)

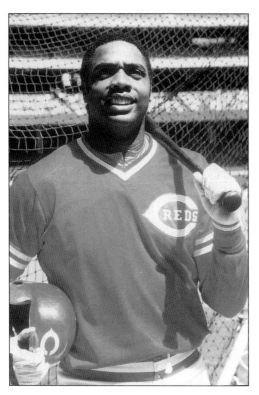

While the Reds were reluctant to enter the era of free agency, they picked up a prize at the end of 1983 in free agent Dave Parker, previously a four-time NL All-Star with the Pittsburgh Pirates. A native Cincinnatian who had sold programs at Crosley Field as a boy, Parker was given the Lombardi Award (for best Reds' offensive player) all four years he played for the Reds (1984-87). In 1985 he had the best year of his career, recording career highs in home runs (34) and RBI (125), while batting .312. Even Parker's departure helped the Reds, who received Jose Rijo from Oakland in exchange for the big right fielder. (Courtesy of Chance Brockway.)

By 1984 Davey Concepcion was one of the last links to the Big Red Machine still on the Reds' roster. In 1982 he was selected to the NL All-Star team for the ninth and final time, and he was voted MVP of the game in Montreal for his deciding two-run homer. He wound up holding several Riverfront Stadium records: for most games (1,213), most at bats (4,151), and most hits (1,123). He also had a penchant for grand slams, finishing third on the Reds' all-time list with six. Concepcion was only the third Reds' player in history unsuperstitious enough to wear number 13. (Courtesy of Chance Brockway.)

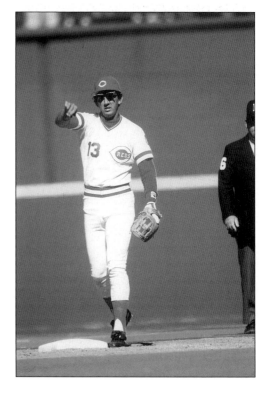

After the last place finishes of 1982 and '83, the Reds were drawing poorly at Riverfront in 1984 and desperately needed a shot of excitement to revive interest in the team. Bringing Pete Rose back to Cincinnati as player-manager was exactly what the doctor ordered. In his second debut with the Reds on August 17, Rose lined an RBI single into left-center field in the first inning. When a Cubs' outfielder misplayed the ball, allowing it to roll to the wall, "Charlie Hustle" kept going around second and slid safely into third, headfirst, as the crowd roared their approval. Rose added an RBI double, and the Reds beat the Cubs 6–4. (Courtesy of *Reds Report*.)

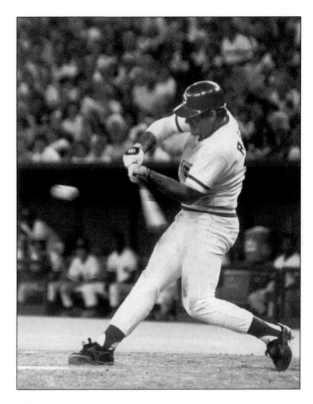

When Pete Rose rejoined the Reds in 1984, the ballclub already had two first basemen on the roster, veteran Tony Perez and youngster Nick Esasky. (A month earlier the Reds had traded away a third first baseman, Dan Driessen, to the Expos. The acquisition of Driessen sent Rose to the Expos' bench and precipitated his return to the Reds.) The Reds described Rose as a "manager-player," to emphasize what they wanted his main duties to be, but Ty Cobb was now in sight and Rose was on a mission to catch him. He wrote his own name into the Reds' starting lineup 23 times in 1984, hit .365, and ended the season with 4,097 hits. (Courtesy of Chance Brockway.)

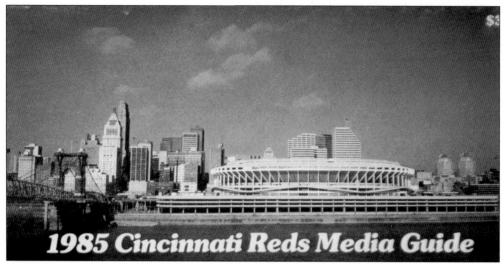

1985 Cincinnati Reds Media Guide

By 1985 Riverfront Stadium had become so identified with the ballclub that the Reds didn't think twice about using nothing but an unidentified picture of the ballpark on the cover of the team media guide. In this instance, Riverfront Stadium trumped player-manager Pete Rose, who entered the 1985 campaign 95 hits short of setting a new record for career base hits. Of course, Rose was the media guide cover boy the following year, after being named Man of the Year (The Sporting News), Athlete of the Year (ABC-TV), and Manager of the Year (UPI). (Courtesy of Tiffany L. Schulz.)

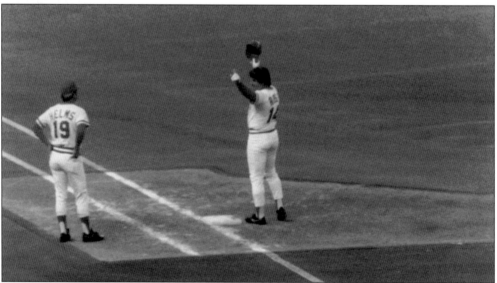

Moments after Rose broke the record, his teammates poured out of the Reds' dugout to congratulate him. At the head of the parade were Reds' owner Marge Schott and 15-year-old Pete Rose Jr. As the crowd of 47, 237 continued to shower him with a seven-minute standing ovation, Rose doffed his batting helmet to acknowledge the cheers and raised his left index finger to indicate that he was number one in hits. Overcome with emotion as he thought about his deceased father and how proud he would have been at what his son had just accomplished, Rose wept on the shoulder of first base coach Tommy Helms, his old roommate and business partner. (Courtesy of Don Cruse.)

The Reds have always been aware of the drawing power of hometown boys, and Marge Schott, who was president and CEO of the Reds for 15 years (1985-99), had an especially soft spot in her heart for them. Her she is with four home grown Reds, from left to right: Ron Oester, Dave Parker, Buddy Bell, and Pete Rose. (Courtesy of *Reds Report*.)

A graduate of Cincinnati's St. Xavier High School, Chris Welsh went 6-9 for the Reds in 1986, his last year in the majors. While trying to work his way back to the big time, he wrote famous author Roger Kahn a letter, claiming that the minor league hitters he was facing were "too dumb to be fooled by a good changeup." He later became a smooth color analyst of Reds' games broadcast on television. (Courtesy of *Reds Report*.)

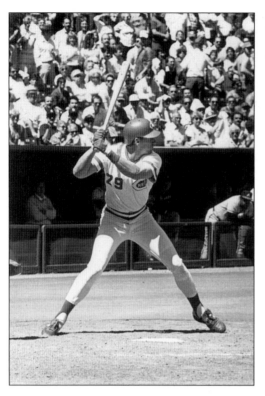

After the Reds made him the number one pick of the secondary phase of the January 1983 draft, Tracy Jones tore through the club's farm system and reached the big leagues in 1986. Known for his all-out hustle, Jones patterned himself after his manager Pete Rose, but injuries prevented him from reaching his potential. He hit .290 in 117 games in 1987 and was traded to Montreal the following year after appearing in 37 games for the Reds. After brief stints with the Giants, Tigers, and Mariners, he returned to Cincinnati and settled into a career as a sports talk radio show host. (Courtesy of *Reds Report*.)

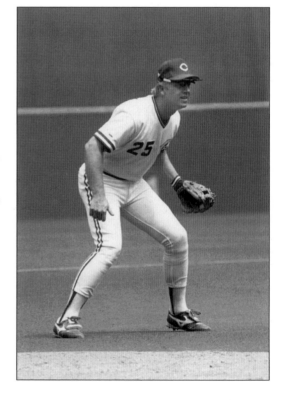

Some of the most sparkling defensive plays ever seen at Riverfront were turned in by third baseman Buddy Bell, the son of former Reds' outfielder Gus Bell. The Reds coveted Bell, an underrated star for the Cleveland Indians and Texas Rangers, for years and finally acquired him from the Rangers halfway through the 1985 season. Bell gave the Reds two solid years before he was traded to Houston after playing 21 games in 1988. Buddy retired after an 18-year career with 201 homers and 2,514 hits. He later managed the Tigers and Rockies and saw two of his sons play in the major leagues. (Courtesy of *Reds Report*.)

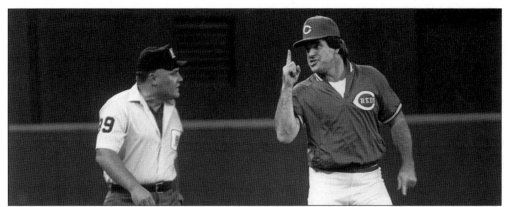

Although he never officially retired as a player, Pete Rose played his last game August 17, 1986, at Riverfront. He struck out in his last at-bat against the Padres' Goose Gossage. His final hit, a single off the Giants' Greg Minton, had come on August 14. How good a manager was Rose? No one has ever published a serious study of the question, but there is no doubt that he was successful. With Rose at the helm, the Reds finished in second place four years in a row (1985-1988), and some people think Rose deserves a lot of credit for developing many of the key contributors to the 1990 World Championship team. Rose's win total of 426 (against 388 losses) places him fifth all-time among Reds' managers, behind Sparky Anderson, Bill McKecknie, Jack Hendricks, and Fred Hutchinson. (Courtesy of *Reds Report*.)

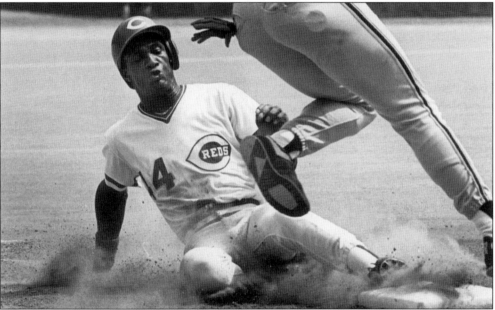

The most talented player to come up through the Reds' farm system in the last two decades of the 20th century, Eric Davis had all five tools. Davis opened eyes around the league in 1986, his first as a regular, by combining 80 stolen bases with 27 home runs. He had his best all-around season the next year when he hit 37 homers, knocked in 100 runs, and batted .293 in 474 at bats. Frequently injured (135 games played was his high), Davis was often criticized for supposedly failing to reach his potential. His career went into decline when he moved on to the Dodgers as a free agent in 1992, but he came back to Cincinnati in 1996 for one more productive season (26 HR, 83 RBI). (Courtesy of *Reds Report*.)

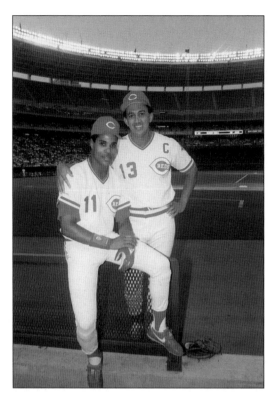

This picture represents a changing of the guard at the shortstop position. It was taken in 1988, Dave Concepcion's 19th and last season in the majors, all with the Reds (a record for consecutive seasons with the club), and Barry Larkin's first as the regular shortstop. Larkin, who came up in 1986, split time with Kurt Stillwell until Stillwell and Ted Power were traded after the 1987 season to the Kansas City Royals for Angel Salazar and Danny Jackson. In 1997 Larkin was named captain of the team, the first time anybody had officially been given the title since Concepcion in 1988. (Courtesy of *Reds Report*.)

The greatest single game performance ever turned in at Riverfront Stadium belongs to Tom Browning, who pitched a 1-0 perfect game against the Los Angeles Dodgers on September 16, 1988. A finesse pitcher who relied on his control, Browning went 20-9 in 1985, his rookie season, and then won in double figures for the next six years. The official attendance for Browning's gem was 16,591, but the actual crowd was certainly smaller as the start of the game was rain-delayed by 2 1/2 hours. Browning's masterpiece took less than two hours. The Reds' lone run came in the sixth on a double by Barry Larkin and a throwing error by the Dodgers' third baseman on Chris Sabo's groundball. Hal McCoy asked Browning to sign his scorebook after the game. It was the only autograph the veteran sportswriter ever asked for. (Courtesy of *Reds Report*.)

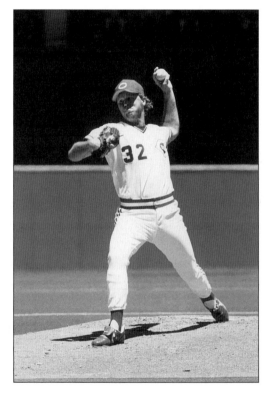

John Franco, a little lefty with guts and a killer slider, led the Reds in saves for four consecutive years (1986-89). After the '89 season he was traded to the New York Mets but remains the Reds' all-time leader in saves (148). He concluded the 2002 season with over 400 saves and is a lock to enter the Hall of Fame someday. (Courtesy of the Topps Company.)

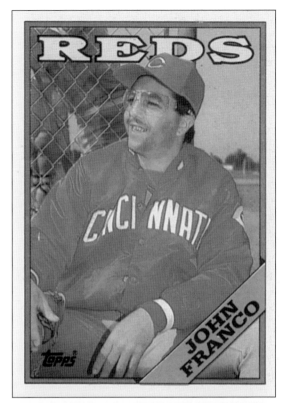

In this beautiful shot of Riverfront from the upper deck down the right field line, the Reds and Dodgers stand on the base lines during pre-game festivities on Opening Day 1989. The sign hanging just below the yellow seat level and behind the left field foul pole says, "It's Reds Time in '89!!" The Reds starting lineup: Larkin (SS), Sabo (3B), Davis (CF), Daniels (LF), Benzinger (1B), O'Neill (RF), Reed (C), Oester (2B), and Jackson (P). (Courtesy of Dr. G. Russell Frankel.)

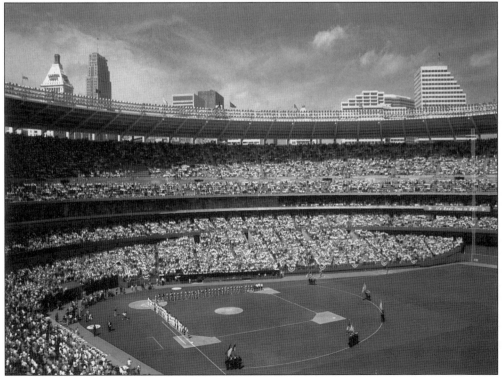

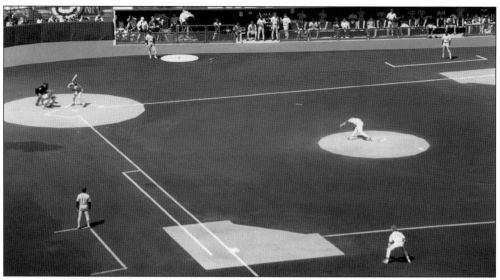

Danny Jackson delivers the first pitch of the 1989 season against the Los Angeles Dodgers before a packed house of 55,385. Jackson was coming off his career-best performance the previous year, his first with the Reds, when his 23 wins (against eight losses) had topped the National League. He had also led the league in complete games with 15. No Reds' pitcher has reached double figures in the category since. Although Jackson didn't get credit for it, the Reds won the game 6–4, for their seventh straight Opening Day victory. Paul O'Neill, with a 4 for 4 day that included a double and a three-run homer, was the batting star for the Reds. (Courtesy of Dr. G. Russell Frankel.)

The Reds stole a real gem from the Oakland A's in 1987 when they acquired Jose Rijo in exchange for Dave Parker. From 1988 until halfway through the 1995 season, when elbow surgery apparently ended his career, Rijo went 92-57 for a winning percentage (.617) that was bested by only two other ML pitchers (Greg Maddux and David Cone). During that time Jose led the Reds in wins three times, in complete games four times, and in ERA six times. Cincinnati sportswriters voted him the winner of the Johnny Vander Meer Award four times. Even more impressive was his successful comeback to the Reds in 2001. Overcoming five elbow surgeries and several failed comebacks, the irrepressible Dominican pitched in 13 games, all in relief, and fashioned an ERA of 2.12. (Courtesy of the Topps Company.)

Six

Another World Championship

The 1990s were a roller-coaster of a decade for the Reds that made manifest the growing economic obsolescence of Riverfront Stadium. Riverfront simply did not provide the additional revenues that the small-market Reds' franchise needed to retain players such as Tim Belcher, Kevin Mitchell, Ron Gant, John Smiley, Jeff Brantley, Jeff Shaw, and Greg Vaughn; all of whom made significant contributions to the team in the '90s. To the surprise of most observers, the decade began at Riverfront with a Big Red Bang. Under new manager Lou Piniella, the Reds became the first team in National League history to go wire-to-wire in first place over a 162-game schedule. Then, after beating the Pirates in the NLCS, the Reds stunned the sports world by sweeping the heavily favored Oakland A's in the 1990 World Series to win Cincinnati's fifth World Championship. Jose Rijo was named MVP of the Series for his 0.59 ERA and victories in Games One and Four; while the batting heroes were Billy Hatcher (.750), Chris Sabo (.563, two HR), and Eric Davis, whose two-run homer in the first inning of Game One at Riverfront got the Reds off on the right foot.

The young champions seemed poised to contend for several years under Piniella, but "Sweet Lou," tired of front office interference, resigned after the Reds finished 5th in '91 and second in '92. The firing of Tony Perez as manager after 44 games, the suspension of Marge Schott for racial and ethnic slurs, and the team's dismal 31-games-out-of-first place finish made 1993 a year to forget. That year's best performance at Riverfront, a four home run/12 RBI game, was even turned in by a visiting player, Mark Whitten of the St. Louis Cardinals. In 1994 the major leagues underwent re-alignment, and the Reds were placed in the NL Central Division. A players' strike, which canceled the last third of the season and the entire post-season, again cheated the Reds, who were in first place when the season was halted. The Reds took their first Central Division flag the next year but couldn't get past the Atlanta Braves in the NLCS.

In 1996 the clock began ticking for the demise of Riverfront Stadium, when Hamilton County voters approved a half-cent sales tax increase to pay for two new stadiums, one for the Cincinnati Bengals and another for the Reds. Finishing third three times (1996-98) and second once (1999), the Reds closed out the decade trying to develop as many top young prospects as possible in order to have a contender when their new ballpark opened in 2003. The new stadium was to be named Great American Ballpark after the insurance conglomerate owned by Reds' CEO Carl Lindner.

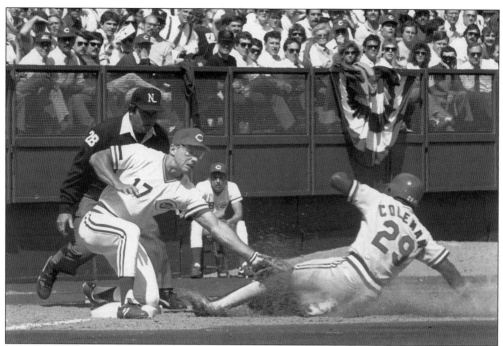

A third baseman out of the University of Michigan, Chris Sabo was a throwback, a plain-spoken, hard-nosed, blue collar-type player. He was voted Rookie of the Year and made the All-Star team in 1988. He slumped a bit the following year but came back in 1990 (25 HR) and 1991 (26 HR, .301) to earn two more All-Star team berths. One of the heroes of the Reds' sweep of the A's in the 1990 World Series, Sabo shunned the spotlight but wound up on the cover of *Sports Illustrated* as the player most representative of the over-achieving World Champions. The first player in the major leagues to wear goggles, he was nicknamed after "Spuds" MacKenzie, the black-eyed dog that starred at the time in television beer commercials. (Courtesy of *Reds Report.*)

A native of Columbus, Ohio, and the son of a former minor leaguer, Paul O'Neill was the right fielder on the Reds' fifth World Championship team. In 1990, his third full season in the majors, he batted .270 with 16 home runs and 78 RBI. His power numbers went up the next year (28 homers and 91 RBI), and he made his first All-Star team; however, he was hampered by a hand injury in 1992 and was traded after the season to the New York Yankees. Skeptics predicted that he would wilt under the pressure of playing in New York, but he became a star in the Big Apple. He hit over .300 six consecutive years (1993-98), made four more All-Star teams, and helped the Yankees reach the World Series five times in a six-year period. (Courtesy of *Reds Report.*)

Joe Oliver had two tours of duty with the Reds (1989-94 and 1996-97) and wound up catching more games (738) for the Reds during the Riverfront Stadium era than any player besides Johnny Bench. Oliver didn't hit much during the 1990 season or the NLCS, but he got hot during the World Series, batting .333. In 1992 he caught 141 games to tie the club record (held by Bench), and Cincinnati sportswriters voted him the MVP of the team in 1993, when he hit 14 home runs and knocked in 75 runs, his career highs. (Courtesy of *Reds Report*.)

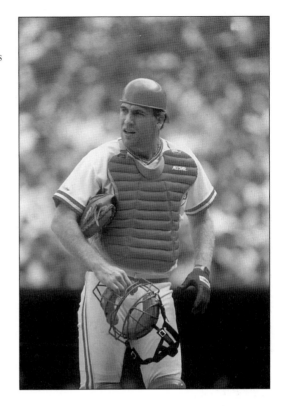

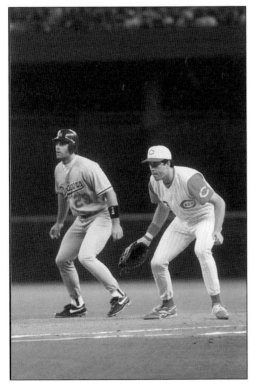

Obtained in trade from the New York Yankees after the 1989 season, Hal Morris was a fixture in the middle of the Reds' batting order for most of the 1990s. Although Morris did not provide much power—16 homers and 80 RBI in 1996 were career highs—he consistently hit for high average. In 1990, when he platooned with Todd Benzinger, Morris batted .340 in 309 at bats. In 1991, when he batted .318, he lost the National League batting title on the last day of the season, and in 1994 he batted .335, fourth best in the NL. Morris' unorthodox habit of shuffling back and forth in the batter's box as the pitch was on the way earned him the nickname of "Happy Feet." (Courtesy of *Reds Report*.)

One of the strengths of the 1990 Reds was the formidable bullpen trio of, from left to right, Norm Charlton, Rob Dibble, and Randy Myers. During the '90 season, Myers earned 31 saves and fashioned a 2.08 ERA; Dibble won eight, saved 11, and recorded a 1.74 ERA; while Charlton chipped in with 12 wins. Dibble led the team in saves (31) the following year; Charlton, the year after that (26). The temperamental Dibble, who struck out 645 batters in 477 innings, was unhittable at times, but arm problems ended his career prematurely. Myers was a league leader in saves three times, and he finished his 14-year career in fifth place on the all-times saves list with 347. This poster, a tribute to the "Nasty Boys" as the three relievers were called, was inserted into a Sunday edition of the *Dayton Daily News* after the World Series.

The batting hero of the 1990 World Series was Billy Hatcher, a journeyman outfielder who spent two and a half of the best years (1990-92) of his career with the Reds. Hatcher went 3 for 3 in Game One and 4 for 4 in Game Two, both at Riverfront, to set a series record of seven consecutive hits. Amazingly, five of the seven hits were for extra bases (four doubles and a triple). Hatcher rapped out two more hits in Game Three in Oakland, but the Series ended for him when the A's Dave Stewart hit him in the hand during his first at-bat of Game Four. He was given the Babe Ruth Award for hitting .750 (9-12) in the Series. (Courtesy of the Topps Company.)

A product of the Reds' farm system who was converted from a shortstop into a center fielder, Reggie Sanders played in Riverfront for most of the 1990s (1992-98). Sanders had power and was a good base stealer, but he struck out a lot and was injury prone. He peaked in 1995 when he hit 28 homers with career highs in batting average (.306) and RBI (90) to help the Reds take the NL Central crown. Frustrated with his inability to stay in the lineup, the Reds traded him to San Diego in 1999. Sanders was a member of the Arizona Diamondbacks' World Series championship team in 2001 and a member of the San Francisco Giants' team which lost the 2002 World Series. (Courtesy of the Topps Company.)

A third-generation major leaguer, Bret Boone came to the Reds (from the Seattle Mariners in late 1993) as a "good hit-no field" prospect and left (after 1998) with a reputation as a flashy fielder and the best second baseman in the National League. In 1998 he led the Reds in home runs (24) and RBI (95) and made his first All-Star team. He left Cincinnati before his father, Bob Boone, became manager, but he did get to play in the majors with his brother, Aaron, who joined the Reds in 1997. After single seasons in Atlanta and San Diego, Bret enjoyed a breakout season in 2001 with his original big league club, the Mariners, for whom he batted .331 with 37 homers and 141 RBI. (Courtesy of the Topps Company.)

On September 9, 1996, Riverfront Stadium was officially renamed "Cinergy Field" when the Cincinnati-area power company paid $6 million to Hamilton County for the naming rights to the ballpark through September of 2001. The Cinergy Corporation later negotiated a cut of $600,000 when the removal of two thirds of the outfield section of the Stadium reduced the number of Cinergy Field signs hanging from the roof from four to two. Although the media immediately accepted the name change, many fans refused to call the ballpark anything but Riverfront Stadium. (Courtesy of Rick Block.)

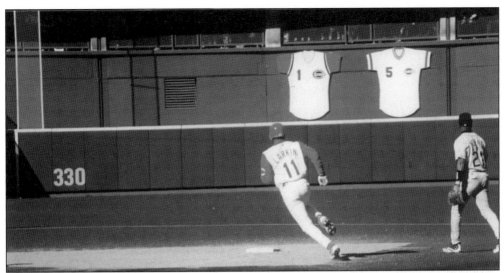

The Reds beat the Colorado Rockies 11–4 on April 1, 1997, to tie the club record for runs scored in an Opening Day game. Barry Larkin, rounding second, walked four times and scored three runs. Larkin, who won the 1995 NL MVP Award, had been the Reds' marquee player for years. At the end of 2002, his 17th season with the Reds, he ranked in the club's all-time top five for eight categories: games, hits, total bases, at bats, doubles, stolen bases, runs, and extra-base hits. (Courtesy of *Reds Report*.)

On September 1, 1997, with his father in attendance and the normal crowd doubled in anticipation of the event, Pete Rose, Jr., made his major league debut. Rose, Jr. had been bouncing around the minor leagues since 1989, but a solid performance at AA Chattanooga (.308 and 25 home runs) and the demands of Reds' fans to see him in Riverfront led to his promotion. Junior thrilled the crowd by copying his dad's crouch in his first at bat and by getting his first major league hit, a single, in his second at bat against Kevin Appier of the Kansas City Royals. Pete Rose, the proud father, said, "He got a hit in the big leagues, and that's something nobody can ever take away from him." (Courtesy of the Topps Company.)

Sean Casey's career was almost over before it started. On April 2, 1998, a couple of days after he'd been acquired from the Cleveland Indians, the gregarious, baby-faced first baseman was hit in the eye with a thrown ball during batting practice. Fortunately, after surgery and rehab, Casey made a full recovery and in 1999 put together the kind of year (.332, 25 homers, 99 RBI) that caused the Reds to regard him as one of the keys to the team's future. Casey proved that the '99 season was no fluke by also batting over .300 in 2000 and 2001. An NCAA Division 1 batting champion at the University of Richmond, Casey slumped in 2002 but remained a favorite of Reds' fans. (Courtesy of *Reds Report*.)

The Reds had high hopes that Brett Tomko would become the stopper the pitching staff had lacked since Jose Rijo was in his prime. Tomko, shown here as the starting pitcher on Opening Day 1999, went 11-7 in 1997 and 13-12 in 1998. He was victimized by the longball in '99 (31 homers in 33 games), and his 5-7 record made him expendable. In February 2000 he was traded with three other players to the Seattle Mariners for Ken Griffey, Jr. (Courtesy of Dr. G. Russell Frankel.)

Danny Graves led the Reds in saves three years in a row (1999-2001) with 27, 30, and 32. In 2001 he was voted both the team's Most Valuable Player and Most Outstanding Pitcher by local sportswriters. Entering the 2002 season his 97 saves ranked him third on the Reds' all-time list, but a lack of dependable starting pitching forced him into the rotation. The first Viet Nam-born player to make the major leagues, Graves has been extremely involved in charitable activities; and so it was no surprise that he was the Reds' player selected to appear on this baseball card, produced by the Disabled American Veterans and given away at Riverfront Stadium during the 2002 season. (Courtesy of the Disabled American Veterans.)

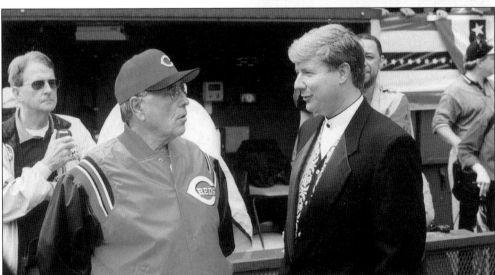

Reds' manager Jack McKeon (left) and GM Jim Bowden discuss the team's prospects for 2000 on Opening Day. McKeon, who replaced Ray Knight in mid-season 1997, was as experienced as they come, having been in professional baseball for 50 years. He was hired to help develop the Reds' many young players, which he did, but failing to win the division in 2000 cost him his job. He left town ranked ninth in wins (291-259) and tenth in winning percentage (.529) among Reds' managers all time. Bowden joined the Reds in 1990, and in 1992 became, at age 31, the youngest general manager in baseball history. In his ten-year reign at Riverfront Bowden proved to be a genius at salvaging player careers thought to be finished and at keeping a small market franchise, the Reds, competitive in a large market world. (Courtesy of *Reds Report*.)

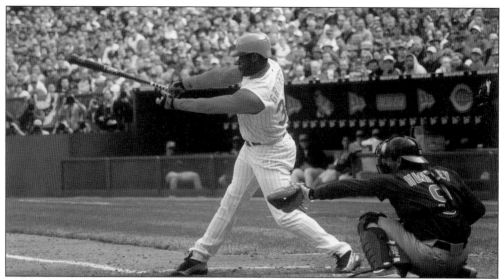

One of the most popular moves Jim Bowden ever made was finding a way to bring Ken Griffey, Jr., a Cincinnati native and graduate of Moeller High School, back to town. Although injuries have depressed Junior's production in Cincinnati, he is still recognized as one of the game's greatest talents. His ten Gold Gloves, seven Silver Slugger Awards, unanimous AL MVP Award (1997), and 11 consecutive berths to All-Star Game starting lineups are merely the highlights of his many accomplishments. He is the youngest player in history to reach 350, 400, and 450 home runs; and at the end of the 2002 season he ranked 20th on the list for career home runs. His best season with the Reds was his first, in 2000, when he hit .271 with 40 home runs and 118 RBI. (Courtesy of *Reds Report*.)

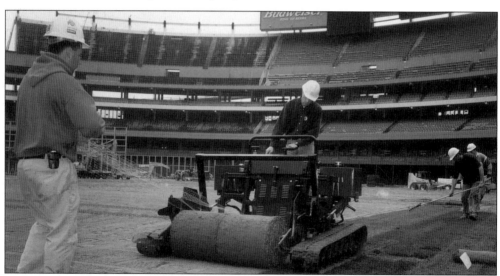

Reds' players, who often complained about the toll artificial turf takes on the body, were thrilled when they learned in the fall of 2000 that they were going to be playing on real grass at the new Riverfront Stadium in 2001. After the old artificial turf and its asphalt foundation were removed, two acres of bluegrass were installed over a base of sand and fertilizer. Besides making life easier for the players, the grass at Riverfront gave the Reds' grounds crew a two-year head start on learning how to care for the grass field at Great American Ballpark. (Courtesy of *Reds Report*.)

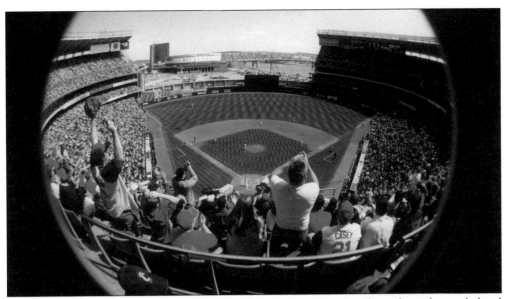

This photo, taken with a fish-eye lens, provides a panoramic view from the red seats behind home plate of the new Riverfront Stadium. This game, Opening Day (April 2) 2001, was the first to be played with the "bite," the large chunk of the stadium from left field to right-center, missing. In addition, for the first time in the Stadium's history, fans saw grass on the field and were afforded a striking view of the Firstar Center (formerly, the Cincinnati Coliseum), the Clay Wade Bailey Bridge, the Ohio River, and the city of Newport, KY. Also new, an 81-foot wide, 40-foot high black wall in center field, erected to provide a proper visual background for the hitters. (Courtesy of Dr. G. Russell Frankel.)

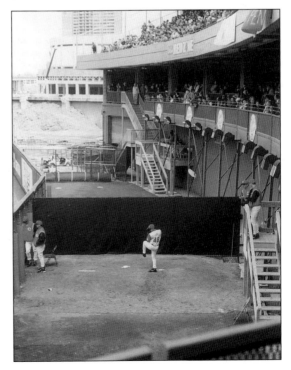

Another significant change to the Stadium was the re-location of both bullpens to an area directly behind the right field wall. The bullpens were originally located in foul ground past the dugouts on either side of the field (compare this photo to the one on page 39). The re-location of the bullpens was made possible because the entire playing field had to be reconfigured to accommodate the construction of the Reds' new home, Great American Ballpark. As part of this reconfiguration, home plate was moved ten feet closer to the grandstands, and the outfield walls were moved in 20 feet. Scott Williamson, shown loosening up on Opening Day 2001, was the first pitcher to use the new bullpens during an actual game. (Courtesy of *Reds Report*.)

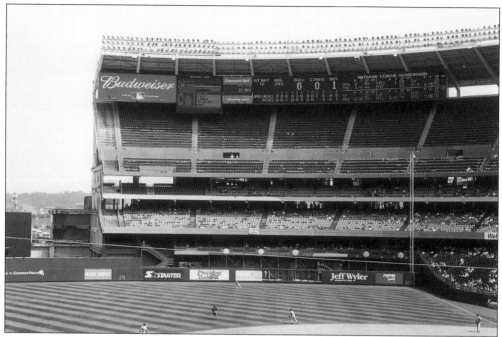

With the "bite" gone, the main scoreboard that used to be in center field had to be moved over into the right field corner. To the right of the Budweiser sign is the JumboTron video scoreboard that first went into operation in May of 1987. Also new for 2001, between the JumboTron and the scoreboard: the Cincinnati Bell electronic board that recorded the speed of each pitch of the game. (Courtesy of the author.)

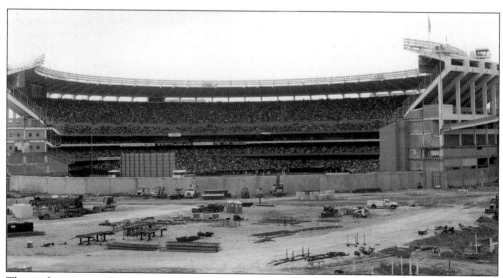

This is the view on Opening Day 2001 of the new Riverfront Stadium from the outside looking in. The building site for Great American Ballpark (foreground) has been cleared, but construction has barely begun. Taking a page out of the Chicago Cubs fans' handbook, a construction worker retrieved a home run ball hit during the Opener by the Atlanta Braves' Rafael Furcal and threw it back into the Stadium. The Reds finished fifth with a 66-96 record in Bob Boone's first year as manager of the team. (Courtesy of *Reds Report*.)

SEVEN

The Final Season

The irony was inescapable. Once the "bite" was taken out of it and real grass was installed on the field, Riverfront Stadium became a more interesting and more inviting place to watch a ballgame than it ever had been before. Similarly, once the 2002 season and the countdown to Riverfront's end began, many fans found it impossible not to feel nostalgic towards the ballpark that had been the Home of the Big Red Machine. There was obviously no turning back though, as Riverfront's replacement, Great American Ballpark, marched day-by-day towards completion right next door.

The Reds occupied first place for 57 days in 2002, but not when it counted. Numerous injuries hampered the team, and a late summer slump dropped them to third place with a sub-.500 record by season's end. Tickets to the "Final Series" (September 20-22) sold out in hours, and the last weekend of major league baseball at Riverfront was looked forward to with great anticipation. Even though the Reds lost all three games to the Phillies, the opportunity to say goodbye was savored by thousands—including more than 50 ex-players, from the Big Red Machine era to the "wire-to-wire" World Champions of 1990, who took part in the post-game festivities on the 22nd. The next night Riverfront hosted one final sell-out: an exhibition softball game between a team of ex-NL All-Stars and a team of ex-Reds' players that was actually an excuse for the reported crowd of 40,192 to give an emotional sendoff to the greatest Reds player who ever played at Riverfront, Pete Rose.

On October 5th the Reds began moving out of their offices at Riverfront. After utilities were turned off two days later, the dismantling of the Stadium began with the removal of the roof canopy, the lights, and the seats. It was then decided that Riverfront would be brought down by implosion, not the wrecking ball; and the O'Rourke Company, the demolition firm given a $5.7 million contract to do the job, began preparing for the razing of Riverfront, set for Sunday, December 29, at 8:00 a.m. With local TV stations providing extensive live coverage, the implosion went off without a hitch. The one-time state-of-the-art ballpark which took two years to build at a cost of $44 million and which served Reds' baseball for 32 years came down in 37 seconds. Like the Big Red Machine, the team that made it famous, Riverfront Stadium was now just a memory.

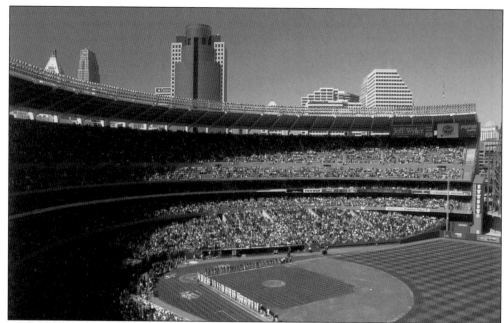

This is Opening Day 2002 shot from Section 236 in the upper deck red seats. A lot has changed since the photographer (Dr. Frankel) took a picture from the same vantage point 13 years earlier (see page 101). Most noticeable are changes in signage, to the configuration of the Stadium, to the skyline above and behind the Stadium, and to the playing field itself. (Courtesy of Dr. G. Russell Frankel.)

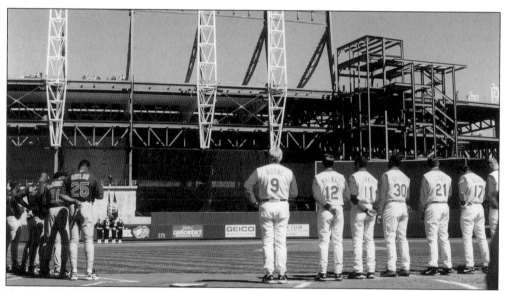

On April 1, 2002, manager Bob Boone's Reds and Don Baylor's Chicago Cubs lined up for the playing of the National Anthem prior to the 31st and final Opening Day baseball game ever played at Riverfront Stadium. Construction workers, who can be seen in the photo in the Reds' Great American Ballpark, had a superb, free view of the festivities. The Reds' last Opening Day lineup: Todd Walker, Barry Larkin, Ken Griffey Jr., Sean Casey, Aaron Boone, Adam Dunn, Juan Encarnacion, Jason LaRue, and Joey Hamilton. (Courtesy of *Reds Report*.)

To commemorate Riverfront's last hurrah, the Reds produced a Final Season logo, which the club displayed on all its printed matter. The red, black, and silver-on-white logo was also fashioned into a uniform patch, which the players wore on their left sleeves. In addition to the columnaded Stadium, the logo features the north end of the Roebling Suspension Bridge and a skyline of downtown Cincinnati. (Courtesy of Tiffany L. Schulz.)

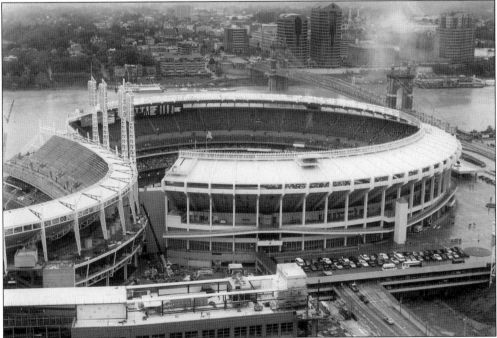

This photo, taken from a high rise in downtown Cincinnati early in the 2002 season, shows a tale of two ballparks: one being built for the Reds' future and the other soon to belong to the team's past. The smoke drifting westward (to the right) over Riverfront is from the fireworks that were set off in celebration of a Reds' home run. The long red brick building under construction in the foreground will house the Reds' new administrative offices. (Courtesy of *Reds Report*.)

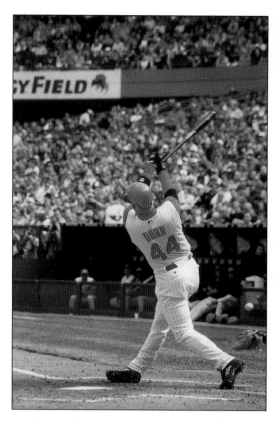

Big (6'6") Adam Dunn, who debuted as a pro in 1998, reached the majors ahead of schedule and excited the Reds and Cincinnati fans with his slugging ability and superstar promise. Dunn started the 2001 season in AA Chattanooga, advanced to AAA Louisville, and then was promoted to the Reds, for whom he hit 19 home runs with 43 RBI in 66 games. 2002 was a tale of two seasons for him. He earned a spot on the NL All-Star team for hitting .300 with 16 homes and 54 RBI but slumped badly in the second half of the year. Nevertheless, he remained in the team's long-term plans as they prepared to move into the new ballpark in 2003. (Courtesy of *Reds Report*.)

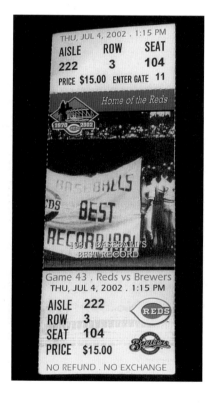

By using a different historical photo on season-ticket tickets every game, the Reds delighted and challenged the collectors who attempted to acquire stubs of all 81 tickets. This full ticket from Game 43 features a photo of the Reds unfurling a banner protesting their treatment during the strike-marred season of 1981. Because the Reds did not win either half of the controversial split season, they were left out of post-season play, despite compiling "Baseball's Best Record." (Courtesy of Tiffany L. Schulz.)

Souvenir pennants have been sold in and around major league baseball parks since the early 1900s. Numerous pennants, many of them celebrating Reds' championships or special events (such as the 1988 All-Star Game), were sold at Riverfront during its three-decades-plus life span. The last pennant celebrated the Stadium itself and the Final Series, scheduled for September 20-22. Made by WinCraft, the leading contemporary manufacturer, the Final Series pennant came with a tag indicating that it was part of a limited edition of 2,500 pieces. (Courtesy of Tiffany L. Schulz.)

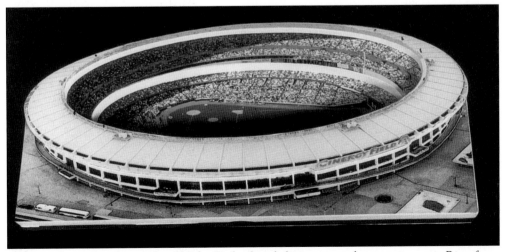

On Saturday night, September 21, the Reds played their next-to-last game ever at Riverfront Stadium. To mark the occasion, all fans in attendance were given a 3-D wooden replica of the Stadium. The Stadium replica measures 9 by 4 inches and can be laid flat or stood on its edge for display. (Courtesy of Tiffany L. Schulz.)

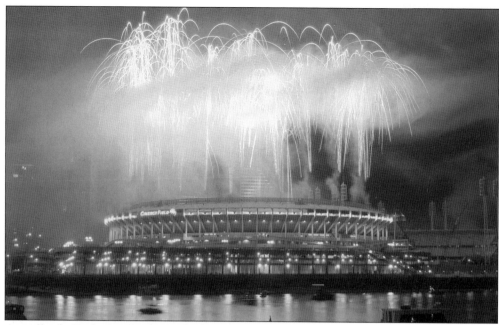

Actually, the Reds played a day-night doubleheader on Saturday because Friday night's game was rained out. A fireworks display that had been scheduled to go off after Friday night's game was thus postponed until after the Saturday nightcap. Even though the Reds lost both games, the spectacular fireworks display helped create a festive atmosphere. (Courtesy of Mark Bowen.)

The next day, on Sunday, all fans in attendance were given one last keepsake: a special "It's History" photo card inside a plastic sleeve, which was attached to a red lanyard imprinted with the date, the Reds' Wishbone C, and the phrase "Final Game." To complete the souvenir, fans slipped their ticket stubs from the final game into the plastic sleeves behind the photo cards, facing outward. (Courtesy of Tiffany L. Schulz.)

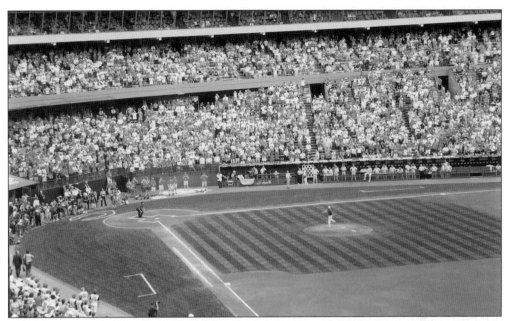

Prior to the last National League game ever played at Riverfront Stadium, on September 22, 2002, between the Reds and the Philadelphia Phillies, Sparky Anderson delivers the ceremonial first pitch to Johnny Bench. (Courtesy of Ken Schenk.)

What is notable about this photo of Ken Griffey, Jr., batting against Brandon Duckworth of the Phillies in Riverfront's final game is the red rose lying in the grass inside the Reds' wishbone "C" behind the home plate circle of clay. Reds' coach Ray Knight placed the flower there to honor Pete Rose, who was not allowed by Major League Baseball to participate in the festivities, along with the other 52 former Reds who did. Reds' fans tossed other roses onto the outfield warning track throughout the game, and when the game ended Tom Browning spray-painted a red #14 onto the pitcher's mound. (Courtesy of Dr. G. Russell Frankel.)

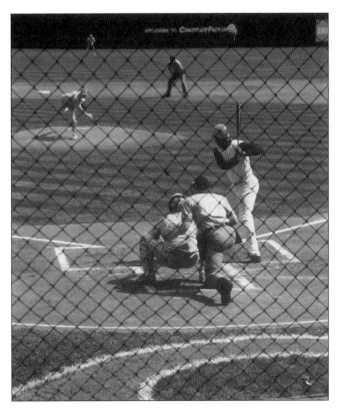

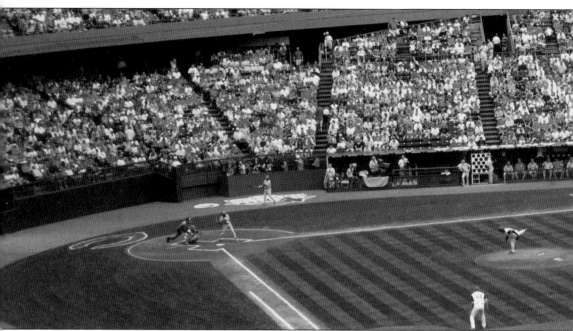

Although he hadn't started a game since June 1, Jose Rijo was given the honor of starting the final game at Riverfront. The decision was popular with Reds' fans, who loved the amiable Rijo for his courage in coming back from serious arm injury and remembered his dominance in the

Second baseman Todd Walker is batting with two outs in the ninth inning and is about to make the last out ever recorded in a NL game at Riverfront Stadium: a 4–3 groundout.

1990 World Series. Even though Rijo was tagged with the 4–3 loss to the Phillies, he received a rousing ovation when he left the game with two outs in the top of the fifth. (Courtesy of Ken Schenk.)

(Courtesy of Ken Schenk.)

Rusty Frankel wanted to do something out of the ordinary to commemorate the historic moment, so he made a photographic montage of the final at bat at Riverfront Stadium. Frankel superimposed two other photos on to that of Phillies' reliever Jose Mesa pitching to the Reds' Todd Walker. At the top, the scoreboard documents Walker's at bat; while in the middle down to the bottom, fans in the red, yellow, and green seats stand and cheer. (Courtesy of Dr. G. Russell Frankel.)

After the last game at Western and Findlay Avenues, Crosley Field's home plate was dug up and flown by helicopter to the Reds' new home on the River. After the last game at Riverfront, the symbolic gesture was repeated. In this picture Riverfront's home plate has just been dug up. It was loaded onto the red Zamboni tractor (which, in the Stadium's artificial turf days, was used to collect and remove water from the field) and driven next door, to the future home of the Reds. (Courtesy of Ken Schenk.)

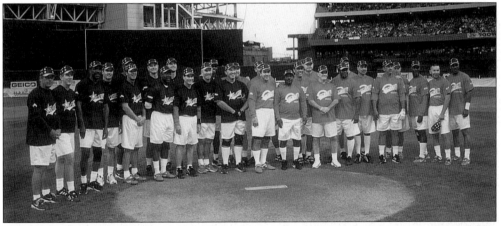

Since Pete Rose was not allowed by Major League Baseball to take part in the Final Game ceremonies at Riverfront Stadium, an old-timers softball game on Monday, September 23, between former Reds' players and a squad of National League All-Stars served as Pete's farewell to the old ballpark where so many of his triumphs had occurred. The two teams lined up for a group photo behind the pitcher's mound before the game. The NL All-Stars are, from left to right, Steve Yeager, John Tudor, Andre Dawson, Ryne Sandberg, Dave Parker, Andy Van Slyke, Steve Carlton, Vince Coleman, Dale Murphy, Steve Garvey, Mike Schmidt, Dwight Gooden, and Gary Carter. The Reds are, from left to right, Rob Dibble, Ron Oester, Johnny Bench, Joe Morgan, Tony Perez, Jack Billingham, Pete Rose, Ken Griffey Sr., Paul O'Neill, Cesar Geronimo, Dave Concepcion, Tom Browning, George Foster, Chris Sabo, and Eric Davis. (Courtesy of *Sports Collectors Digest.*)

Before the game, won by the NL All-Stars 19–4, Rose guaranteed one thing: "You will not see me do a headfirst slide. To be honest with you, I don't think I can get going fast enough to do one. But I will get a hit." In the sixth inning Rose got his hit, a line drive past former Phillies teammate Mike Schmidt at third. He moved to second on a single by Joe Morgan and then, after a fly ball, tagged up and belly flopped safely into third. Although it wasn't pretty, the hustle was quintessential Rose and brought down the house. In the following day's edition, *The Cincinnati Enquirer* quoted a woman whose reaction to Rose seemed to speak for the entire sell-out crowd: "He is special. We love him and always will." (Courtesy of *Sports Collectors Digest*.)

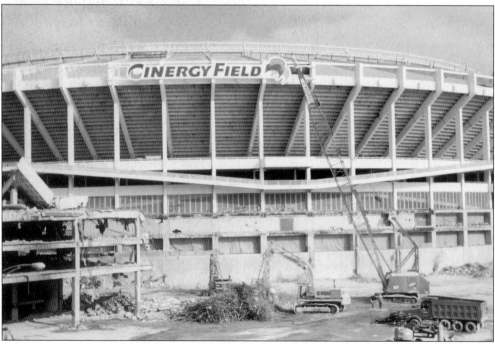

Taken from the John A. Roebling Bridge a few days before Riverfront was imploded, this photo shows O'Rourke Company workers tearing down portions of the three-story parking garage that surrounded the Stadium. (Courtesy of the author.)

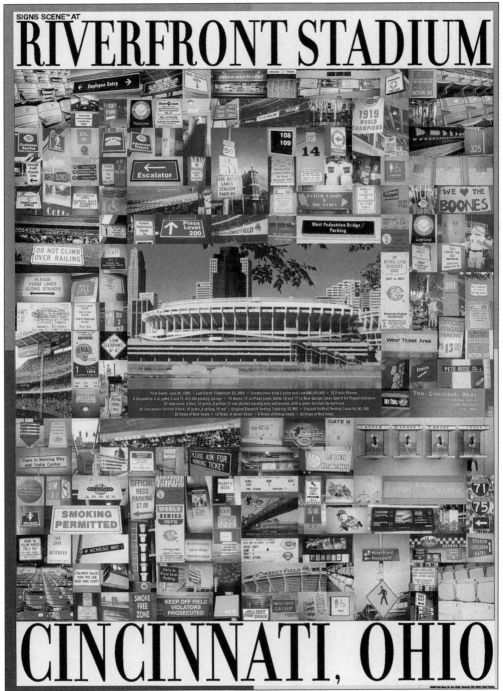

Of all the items made to commemorate Riverfront Stadium, the most ingenious was this poster called "Signs Scene at Riverfront Stadium." It is made up of 175 color images of virtually every sign in and around the stadium. (Courtesy of Rick Block.)

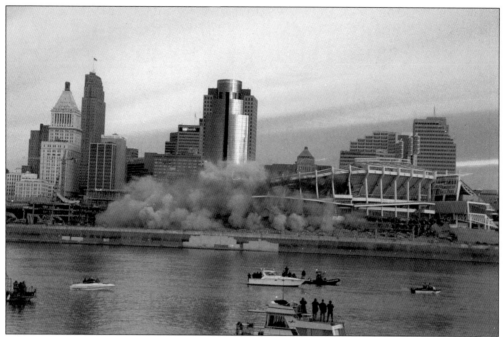

To accomplish the implosion, more than 2,000 holes were drilled into the concrete columns of the Stadium and filled with 1,400 pounds of explosives. A sequence of detonations lasting nine seconds caused the 18 load-bearing columns to crumple inwards in a counter-clockwise fashion, from the northeast corner to the southeast. (Courtesy of Tiffany L. Schulz.)

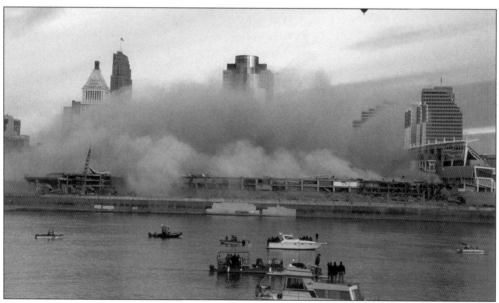

The implosion brought 9,500 tons of structural steel, 70 miles of reinforced concrete, and 600,000 sq. feet of masonry crashing down into a ring of rubble and raised a huge cloud of dust and debris. When the dust settled, the most dramatic change in the Cincinnati landscape to occur in three decades was evident. The end of Riverfront Stadium was the beginning of a new era for the Queen City. (Courtesy of Tiffany L. Schulz.)